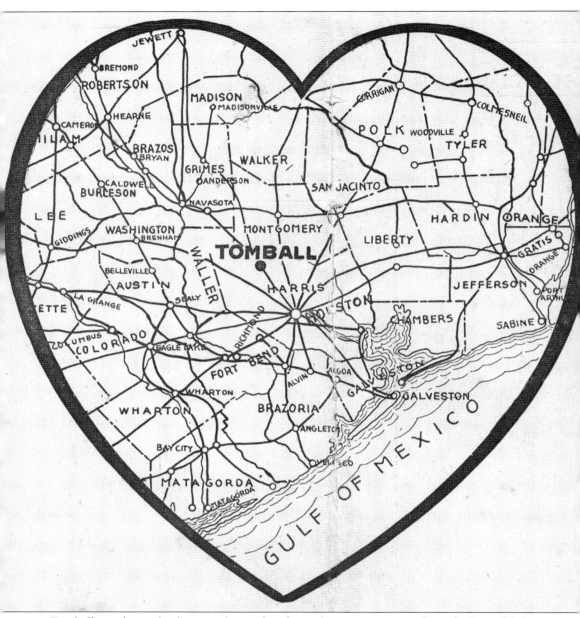

Tomball was the perfect location for a railroad stop due to its proximity from the Port of Galveston northward to rail stations in Fort Worth. Land was marketed for sale in the early 1900s with the reference being the heart of the famous Texas Gulf Coast rain belt. The town still carries the heart reference today, with the catchphrase "Hometown with a Heart" displayed on many items. (Courtesy Tomball Museum Center.)

ON THE COVER: In 1933, black liquid gold was discovered in the Tomball area for the first time on the Kobs well west of town. Oil launched the little town into a thriving city, but residents still enjoyed the peaceful country life while embracing what the discovery provided. Children from an oilfield family overlook the pasture at the Kobs well storage tanks. (Photograph by Esther Bubley, courtesy the University of Louisville Archives.)

IMAGES of America
TOMBALL

Lone Star College-Tomball Community Library

Copyright © 2025 by Lone Star College–Tomball Community Library
ISBN 978-1-4671-6172-5

Published by Arcadia Publishing
Charleston, South Carolina

Printed in the United States of America

Library of Congress Control Number: 2024938201

For all general information, please contact Arcadia Publishing:
Telephone 843-853-2070
Fax 843-853-0044
E-mail sales@arcadiapublishing.com

Visit us on the Internet at www.arcadiapublishing.com

To all who consider the town of Tomball to be a family within itself or hold strong to those family roots that were embedded in its early growth, this history is a testament to the love for Tomball that we all share today. To you, we dedicate this book; to all who have passed through, lived, loved, and cherished the town and have worked to provide meaning to our "Hometown with a Heart."

Contents

Acknowledgments		6
Introduction		7
1.	The Early Years	9
2.	Early Settlers and Settlements	25
3.	"Oil Town USA"	35
4.	Businesses and Farms	45
5.	Serving the Community	59
6.	Organizations	69
7.	Education	79
8.	Community Life	91
9.	Favorite and Familiar Places	103
Bibliography		127

Acknowledgments

This pictorial history of Tomball could not have been completed without the dedication and countless conversations of historical reference from those who continue to cherish their ancestors and memories of their "Hometown with a Heart." A complete list of every individual who contributed in some way to this book would consume several pages, so to those we are unable to list, we say "thank you" for your dedication to keeping this history alive. A special hug goes to the Friends of Tomball Committee, which spent many hours researching and putting together the photographs that brought this book to life. Unless otherwise noted, all images appear courtesy of Lessie Upchurch.

Introduction

For the past 125 years, many hardworking and talented people have made their mark in the establishment of this small town, creating a beautiful city with a heart that for many generations has filled dreams for a better life. In 1906, after a depot was built that became the first commercial building on an empty prairie, the city of Peck was formed and named after the chief engineer of the Trinity & Brazos Valley Railroad. This terminal became a pivotal stop in the northwest section of Harris County due to its perfect geographical location at the end of rolling hills with low depressions. The terminal included a freight station with a depot, telegraph office, water station, stock pens, and five-stall roundhouse. The railroad employees and their families, along with current landowners who had immigrated through the Port of Houston in the early 1800s, brought prosperity to this sparsely inhabited prairie.

William Malone Realty Company purchased unsold lots in Peck with some surrounding acreage from the Valley Route Townsite and Loan Company. The town was resurveyed and platted under the new company name of Tomball Townsite Company. On December 2, 1907, Malone renamed the town "Tom Ball" and dedicated it in honor of the railroad's attorney, Thomas Henry Ball, who was instrumental in bringing rail transportation through the area. In 1912, the company sold its holdings to the Linebarger Brothers Realty Company, which marketed lots through mail-order advertisements that included the pitch that lots were "big enough for a Texas oil well." The railroad boom lasted only until 1914, when the impending war in Europe affected many businesses across the country. The Trinity & Brazos Valley Railroad collapsed, service stops in Tomball ceased, and the town slowly stabilized from the quick growth of businesses and people to a quiet rural family town.

The focus in the area turned from shipping to drilling. As many workers and families had moved in during the Linebarger land rush, the search for a new commodity was in full force. In 1932, when the first oil well was erected, a new growth in the town's population began. When black gold was struck in 1933, the quiet little farming and ranching community soon became known worldwide as "Oil Town, USA." Fields and wells were purchased and managed by companies such as Humble Oil and Refining Company, the Texas Company, Amerada Petroleum Company, Magnolia Oil, Shell Oil, Sun Oil, and many others. Humble Oil held the largest share of the land and established a base of operation on the southwest side of town, soon to be known as Humble Camp. Here, employees and their families were provided with housing and amenities that quickly enveloped the town of Tomball and created a new era of housing and commerce.

From the mid-1930s up until the late 1950s, Tomball grew at a tremendous rate, bringing new businesses each year to meet the demands of its population. Police and fire departments formed, a growing medical field brought a new hospital and doctors, and hotels and several new schools were quickly built to meet the demands of growing families. By 1955, oil production began to slow, and the once-thriving Humble Camp slowly phased out all the amenities that had been afforded to oil families. In 1957, the last Humble Camp house was moved into town, and the manicured yards of Humble Camp became pastures for cattle. Just as during the years of the shift from trains to oil,

the 1950s and 1960s were a period of stabilization of family and community. Tomball continued to prosper with a dedicated school district that attracted new families, and the community developed many organizations that are still in place today. The city celebrated special milestones at the Diamond Jubilee celebration in 1982 and its centennial in 2007.

The city has grown over the years. Many old businesses have disappeared or changed hands, and the growing city of Houston and surrounding towns have made the transition from city to country life almost invisible. Schools, services, and city government have kept up with the pace of rapid growth, even as the small town itself has slowly disappeared into a metropolis of businesses and subdivisions. As the city continues to develop into an economically diverse and prosperous community, industrial, technological, retail, educational, and community institutions have risen to meet the needs of its citizens.

When my mother, Lessie Upchurch, began researching Tomball in 1973, it was interesting and easy to uncover all the stories and rich history that many of the pioneers or their direct descendants were eager to share. Whether it was their grandparents' birth abroad, or how their family had built roots that helped shape early Tomball, the residents were a walking history book in themselves. When *Welcome to Tomball* was released in 1976, my mother was proud of the history she was able to gather and publish—not only for herself but for all the families that were a part of the town they all cherished. Many books and articles have since been published about the town, but with each story that is told and each family's version of their heritage, it is clear there is still so much to be documented about the town. One dreams about the chance to uncover facts that may change the way an event is viewed. Through each period of growth for Tomball, the city has managed to keep old traditions alive, and it continues to honor its rich heritage and maintain the small-town appeal, which residents proudly named "Hometown with a Heart."

It became clear while researching this book that the residents whose roots are grounded in a small-town atmosphere feel every action of history: its growth, its happy times, and its troubled times. This book is another great collection of these continued stories through the compilation of old and newly discovered photographs of Tomball residents and their ancestors. Tomball continues to stand proud among cities of its size; it is a city of friendliness, strength, courage, and honesty. Its residents enjoy the benefit of big city industry and technology while being comforted by the tranquility of small-town living.

—Lisa Upchurch Bodway

One

THE EARLY YEARS

To better understand Tomball's formation, early growth and what drew people to this area of land needs to be explored. When Stephen F. Austin was commissioned to colonize land in the mid-1800s, he used the Republic of Texas's land grant program for distribution. A person could also be granted 320-acre tracts as payment for services rendered to the Army of the Republic of Texas. Large sections of land in the Tomball area were granted to three men in this way: Joseph House, William Hurd, and Ralph Hubbard. House's land is the area known as Rosehill, while Hubbard's to the east is called Hufsmith. William Hurd's section became the town of Tomball. These original areas were platted by the state in 1841 and were briefly known as the County of Spring Creek.

Spring Creek was rich with piney woods and cool creek water, which attracted people from Europe seeking a new life. Longhorn cattle had been abundant long before the area became farmland. Founding families required timber to build houses, barns, and wagons, which attracted experienced lumbermen. Around 1850, C.W. Winkler bought a German-manufactured sawmill and had it shipped to Texas, founding one of the earliest sawmills. Once homes, barns, and wagons were completed, founding families turned their attention to expanding their farmland. Cotton was one of the first commercial trades, as the climate was perfectly suited due to the seasonal adjustments. Situated at latitude 30 degrees 33 minutes and longitude 90 degrees 37 minutes, this area was marked as the highest level of elevation of all counties surrounding the Port of Galveston. As cotton and vegetables began to travel along the railways, commercial buildings soon cropped up to provide staples and services for settlers. By the time the town was named in 1907, the small rail stop had a general store, saloon, hotel, doctor's office, water tower, and railroad depot. From Peck to Tomball Townsite Company to Tom Ball and, finally, Tomball, the settlement evolved into a prosperous community.

Before houses, barns, fences, and wagons could be built, timber was needed. Before the railroad and oil derricks could be built, there had to be lumber. Pictured is the thick wooded landscape that covered the area in the late 1890s.

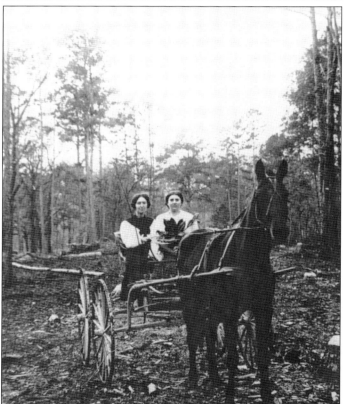

Settlers ride through a freshly cleared timber area west of Tomball in the early 1900s. One of the oldest sawmills from the 1870s was the Charles Kriegle Sawmill, located in the southern part of the area.

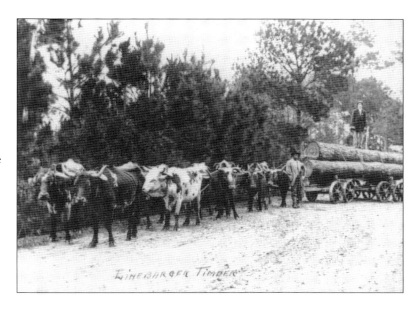

The Linebarger brothers, who owned a sawmill, are pictured hauling cut timber by teams of oxen. Clayton, Forrest, and Clarence Linebarger were entrepreneurs of the area who purchased the town in 1912 and marketed the land for sale.

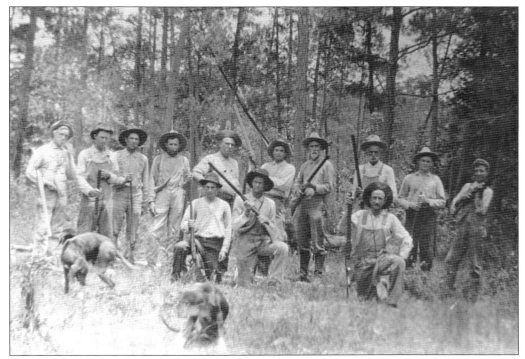

As written in a 1912 article in the *Tomball Enterprise,* hunting was bountiful in the area and attracted many area sportsmen. For many, ducks and quail were a "daily sport," while the abundance of raccoons and large fishing holes provided additional sporting opportunities. Hides from these animals and others were shipped via rail from the train depot to destinations throughout the state and country. This hunting party includes the families of Brautigam, Mahaffey, Parker, Laird, Young, and Dulaney.

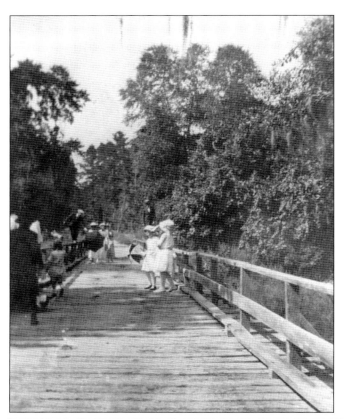

The area around Spring Creek on the north side of Tomball attracted families as a favorite place to socialize, picnic, and play games. Pictured are families enjoying the creek and the area on Spring Creek Bridge.

Families play stickball (early baseball) by Spring Creek around 1908. Spring Creek begins in Waller County, travels through Harris and Montgomery Counties, and then empties its natural spring water into the west side of the San Jacinto River near the Highway 59 bridge.

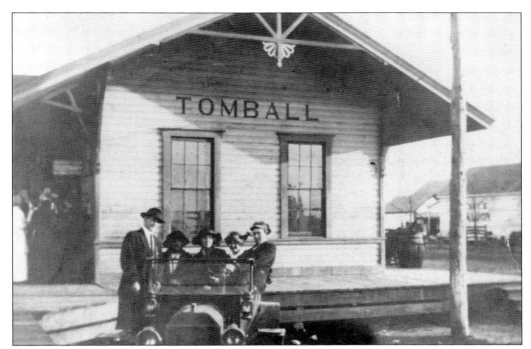

The Trinity & Brazos Valley Railroad, headquartered in Fort Worth, acquired its first right-of-way in this area for the extension from Teague to Houston in 1905. By 1906, prospectors and realty companies had bought most of the land near the railroad right-of-way. The depot, known to be the first commercial building at the new site, was the nucleus that led to the beginning of Peck.

From Fort Worth to Galveston, there were 40 train stations. The five-stall roundhouse, completed in early 1907 and managed by Johnny B. Hearne, was used until 1914. It was destroyed in the 1915 hurricane.

13

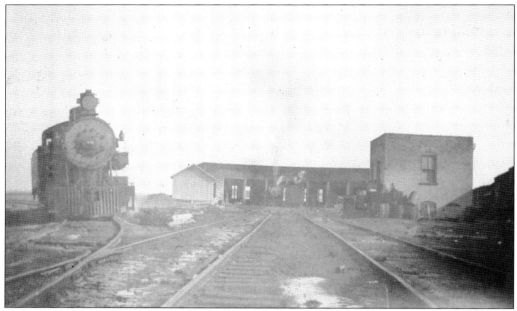

On January 27, 1907, the first freight train, engineered by Jim Posey, entered the terminal in Peck. The terminal included a freight station with a depot, a telegraph office, a water station, two section houses, four stock pens, and a roundhouse. Tomball became a routine stop for the railroad for the loading and unloading of goods and travelers, which in turn powered the quick growth of the small railroad town.

Freight cars wait at the switching station in Tomball in 1913. Tomball was a switching point between Galveston and Teague. A locomotive could pull more weight from Galveston to Tomball but had to lighten cars or unhook to travel from Tomball to Teague because of the upward incline of the terrain. (Courtesy Sam Houston State University.)

This view of the tracks in the early 1900s looks south into the train terminal. On the right are the water tower and train depot. Farther to the right are the Townsend Hotel, Hoffman home, Hoffman General Store, Hoffman Saloon, Klein Hotel, and farthest back, the Tob Henry Saloon. On the left side of the tracks is the Hegar Hotel. Charles F. Hoffman was the first resident and merchant recorded for Peck.

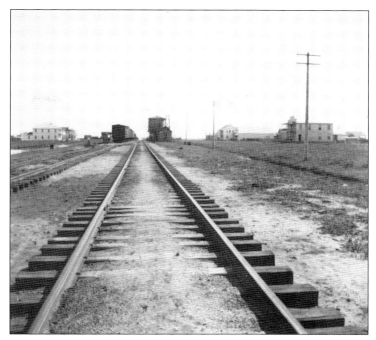

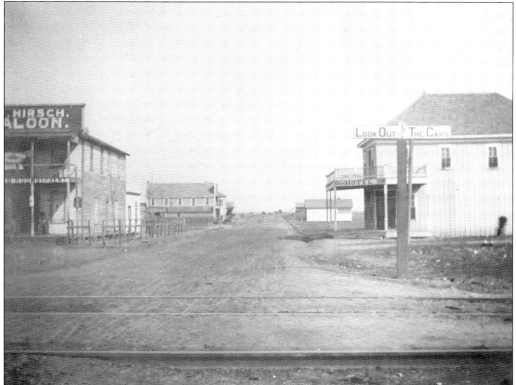

Looking east across the tracks, to the right are the William Hirsch Saloon and the Charles Mahaffey General Store. To the left is the Delane Hotel. The Delane family came to Tomball from Columbus, Texas, and the hotel was also known as the Yellow Dog Hotel in about 1906.

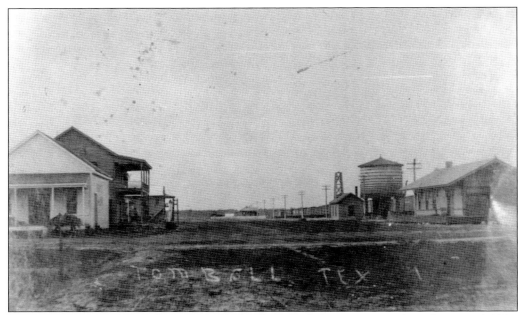

This view looks north up Elm Street with the depot and water tower on the right around 1907. Buildings on the left are the Hoffman Saloon, the Hoffman General Store, and the Hoffman homestead under construction.

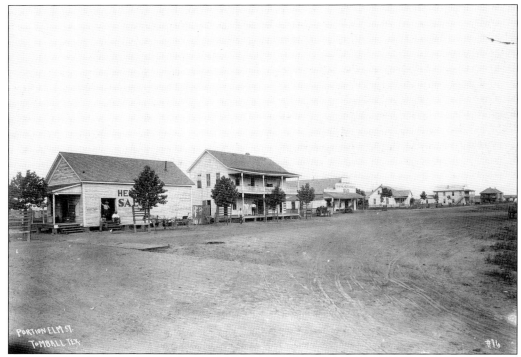

This c. 1923 photograph is of the same businesses above and shows the growth the town had experienced. From left to right are the Tob Henry Saloon, the Klein Hotel, the Hoffman Saloon, the Hoffman General Store, the Hoffmans' residence, the Hegar/Simpson Hotel, and then the Wheeler Hotel, also called the Railroad Hotel.

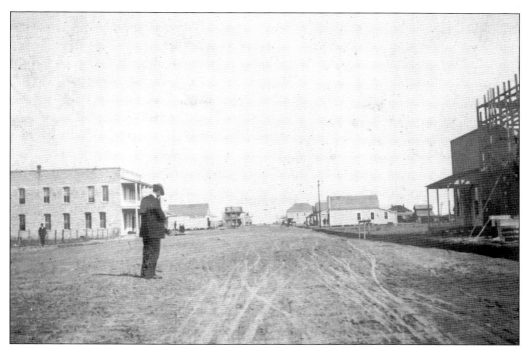

Looking east on Main Street to the railroad tracks shows the two-story Brick Hotel on the left, Tob Henry Saloon at the northwest corner of Elm and Main Streets, then the William Hirsch Saloon. On the right, from front to back, are the Wilburn General Store, Wilburn Hardware, and the Charles F. Hoffman Bank, and in the distance is the Delaney Hotel.

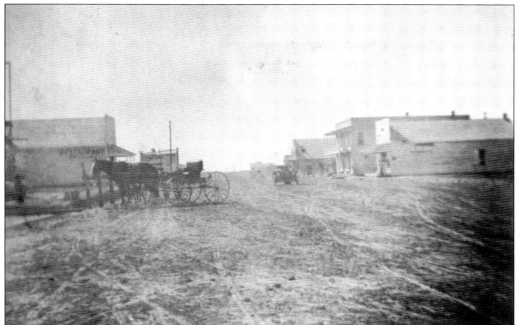

On Main Street at the tracks looking west, notice the car coming down the center of the street. On the right, from front to back, are Dr. J.J. Trichel's house and office, the two-story Brick Hotel, and Terrell's Dry Goods in the distance.

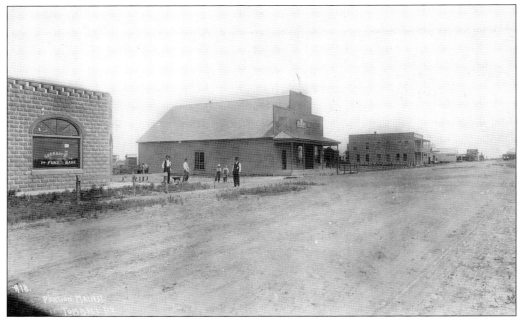

In the 200 and 300 blocks of West Main Street, looking east, are the redbrick First State Bank of Tomball, Terrell's Dry Goods, and the Brick Hotel. First State Bank was built in 1910 on the corner of Cherry Street, incorporated and established by local businessmen. The bank invested in some of the early oil exploration efforts. Terrell's Dry Goods was built in 1908 and operated until the mid-1940s.

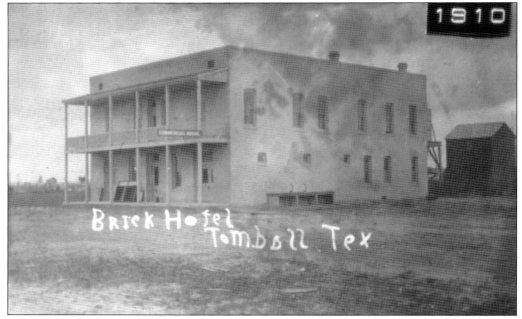

The Brick Hotel, at 200 West Main Street, was built in 1908. Dr. Trichel later bought the hotel and placed his office and a drugstore on the first floor. In the corner of the first floor was Tomball's first post office. The building was partially destroyed by fire in 1935 and was bought by William Holderrieth. He operated Tomball Furniture Company until a fire in the 1980s destroyed the building.

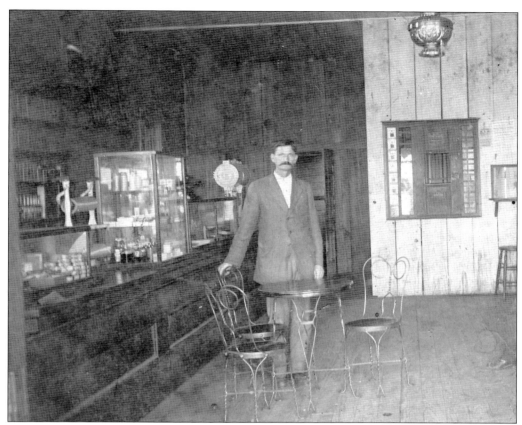

Dr. Trichel built a new drugstore at 118 West Main Street and moved the post office from the Brick Hotel. Pictured here is Otto Hegar, the first Tomball postmaster. Post office boxes can be seen on the back wall along with dry goods and medicine in the glass cabinets. Trichel also built the first telephone system and switchboard, which he and his wife operated.

Terrell's Dry Goods was built in 1908 on the north side of Main Street, two blocks west of the tracks. R.Q. Terrell and his wife, Annie, were the first owners, and then his brother bought the business and operated it until the 1940s.

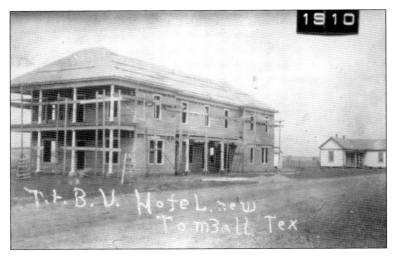

The Wheeler Hotel, built by W.W. Wheeler in 1910 at 400 North Elm Street, was also known as the Railroad Hotel. W.W. Wheeler and his wife ran the hotel with help from their daughter Myrtle Wheeler Klein. Florence Wheeler was a midwife and assisted Dr. J.J. Trichel with many deliveries.

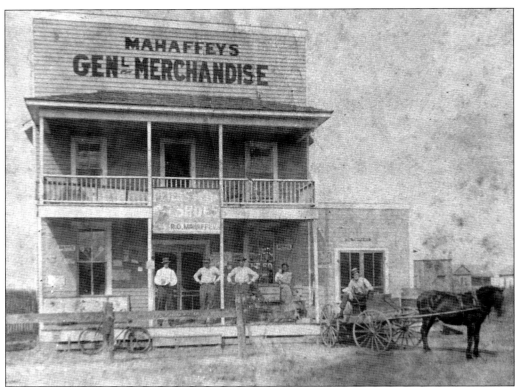

Mahaffey Merchandise was built east of the railroad tracks by Robert Mahaffey in 1908. Robert's daughter Hazel was the first baby born in Tomball. The living quarters were upstairs and the store downstairs. The building was later moved to the west side of Main Street on skids powered by a mule team. It was later sold to Dora Metzler Coleman, and the second story became home to the first Masonic Lodge and Eastern Star chapters in Tomball. The store was finally closed in 1964.

The Community Building was erected around 1929 on the corner of Oak and Market Streets. The building held graduation classes, church services, boxing matches, picture shows, and community plays and parties. The local fair used the building to display entries, and the Future Farmers of America built pens to display their animals. It was later moved to the Tomball Fairgrounds on Cherry Street and used as an exhibit hall.

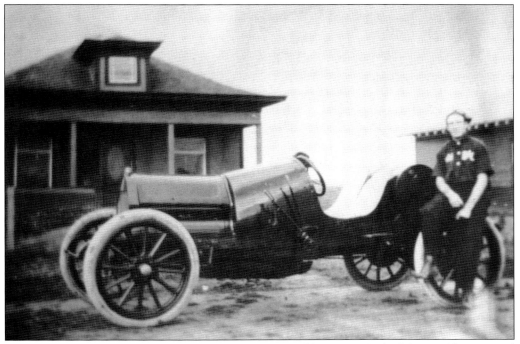

Clarence A. Linebarger is pictured in front of his car and house on Oxford Street. Clarence and his brother Forrest were early settlers and contributors to the town. In 1912, Linebarger Brothers Realty Company bought the town of Tomball for $20,000. Keeping original business lots the same size, they cut residential lots in half to double the number available to new buyers found through a statewide marketing campaign.

21

In this view looking south down Elm Street, the railroad water tower is on the left by the railroad tracks. The house in the center was the Hoffman home. Charles F. Hoffman was the first business owner of Peck.

Thomas Henry Ball was born in Texas and became a prominent lawyer and US congressman. Instrumental in the creation of Buffalo Bayou, Ball was an attorney for the Trinity & Brazos Valley Railroad. Ball dedicated himself to bringing the railroad through Peck as it made its way to the port. Feeling the town would not have flourished otherwise, town owner William Malone dedicated it as Tom Ball in 1907.

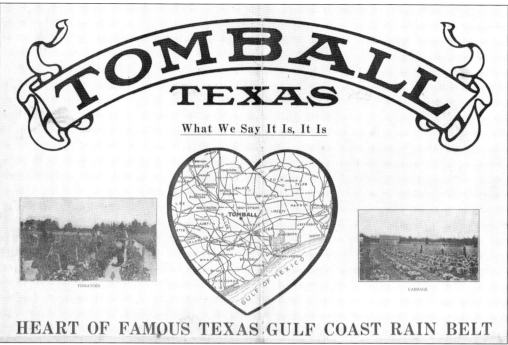

HEART OF FAMOUS TEXAS GULF COAST RAIN BELT

Tomball was sold in 1909 to A.E. Clark, who formed the Tomball Townsite Company. The townsite formation divided it into business and residential tracts. The town was sold again in 1912 to the Linebarger Brothers Realty Company of Dallas for $20,000. Linebarger Realty brought in a marketing team to photograph and distribute this multi-page land pamphlet that highlighted photographs and facts about the land for sale.

The Ideal Place for Your Home. The Logical Place for Your Investment

DIVISION POINT ON TRINITY AND BRAZOS VALLEY RAILWAY (Rock Island--Frisco System)
Round House and Shops with Splendid Pay Roll Already There

OWN a home where nature smiles, where the Balmy Gulf Breeze blows, where you can work and be out of doors every day of the year, where splendid opportunities exist, where fortunes are being made daily from the rapid increase in land values and in a country that is to-day attracting more attention and drawing more people than any other section of the United States.

TOMBALL has wonderful natural resources, the ideal geographical location, the splendid elevation, the fresh gulf breeze, the absence of mosquitoes, the perfect natural drainage, the purest water; and surrounding it, there lies a country as fruitful and abundantly endowed by nature as can be found on the face of the earth.

Only a Limited Number of these Lots are being Offered at this time at Attractive Opening and Introductory Prices. Grasp Opportunity NOW—Our Prices will Positively be Advanced.

LINEBARGER BROS. REALTY CO., OWNERS
302-303 Guaranty Bank Bldg., Dallas, Texas

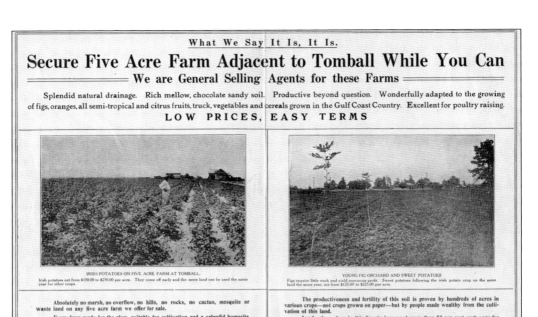

These are pages from the pamphlet showing marketing facts and photographs, including the brick high school of 1910, the train station roundhouse, and various farms and produce. The advertisement uses the phrase "What We Say It Is, It is" on the front and names the area the "Heart of Famous Texas Gulf Coast Rain Belt" with the area map in the shape of a heart.

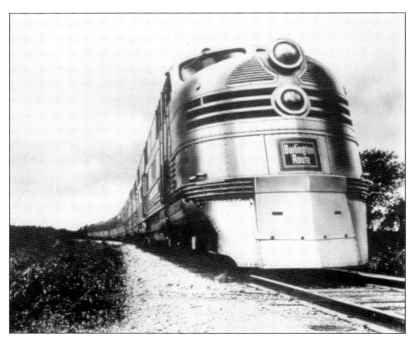

The steam locomotive was active for many years, but as time passed, new diesel engines began to make their way along the route. One of these new diesels, the Sam Houston Zephyr, planned to pass through Tomball for the first time in 1936. Hundreds of people gathered to celebrate and see the train. (Courtesy C.L. Morris, CRO&P-FW&D Railway.)

Two

Early Settlers and Settlements

In addition to the 1,600 acres granted to William Hurd in 1938, Joseph House and William Hubbard were also granted land in the surrounding areas. This land and the early pioneers were considered part of the greater Tomball area and contributed to the growth of the conjoined territories that eventually became one community.

To the west was an area owned by Joseph House named Rosehill. The name "Rosehill" has several stories that could explain the name, but the most favored is that it was named for the wild roses that still grow in the fields today. In the mid-1800s, Rosehill became a dominantly German settlement. Early settlers included Hillegeist, Hoffman, Kobs, Metzler, Hirsch, Rudel, Holderrieth, Theis, Scholl, and Beckendorf. On the far west side of Rosehill is an area known as New Kentucky, which is famous for Sam Houston and his army camping under the large oak trees a few days before the battle at San Jacinto.

To the north was an area granted to Isaac Decker in 1834. Decker was from Canada and was a tanner by trade. He made harness gear for horses and shoes for the troops. Decker's home was in the area now known as Wright Road. Decker had three marriages resulting in 20 children. Early settlers of Decker's Prairie included Brautigam, Fritz, Seidel, Kobs, Freidrick, Coe, Winkler, Baker, Neidigk, and Weindorff. This area, most popular for lumber and early sawmills, was closest to Spring Creek. Over time, the name changed to Decker Prairie.

To the east was the area granted to William Hubbard. Early settlers included Oualline, Vogt, Bogs, and Steubner. The settlement needed a name, and much like the naming of Tomball, the name Hufsmith was chosen to honor Frank Hufsmith, superintendent of the railroad.

To complete the circle, to the south is the area first known as Willow, then Willow Creek. It began on the southwest side of Rosehill and joined Spring Creek directly south of Tomball. Early settlers included Pillot, Mahaffey, Spell, Bonds, Newton, and Jobson.

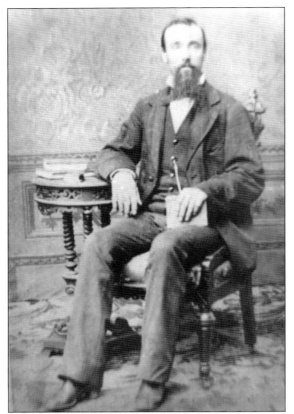

Dr. Jacob Frederick Wilhelm Metzler was the son of Jacob Metzler, who came to the Tomball area from Germany in the early 1850s. Dr. Metzler was born in Rosehill in 1856. After attending medical school in Galveston, he returned to Rosehill to begin his practice when he was 24 years old. Along with a medical office in his home, he eventually had a general store, cotton gin, post office, blacksmith shop, and saloon. In 1908, he built a two-story home and moved his family to Tomball, continuing his practice in addition to having a drugstore in the office. The photograph below is of the buggy car owned by Dr. Metzler that he purchased from Sears, Roebuck and Company, produced in 1907. Dr. Metzler made many house calls in this car, thought to be the first car in Tomball. (Both, courtesy Arther Kobs.)

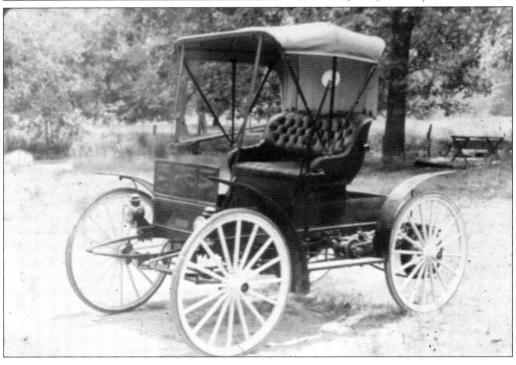

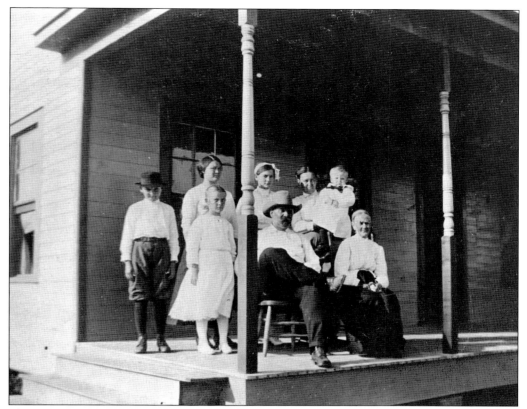

The Fritz Theis family is seen in this image taken on the front porch of their home around 1913. Pictured are, from left to right, (first row) Sybil, Fritz, and Ernestine; (second row) A.W. (Allie), Ola, Nora, Mary, and Dan. Fritz Theis was a constable in the area before Peck was formed and a son of Henry Theis. Henry came with his parents from Germany to Rosehill in 1846.

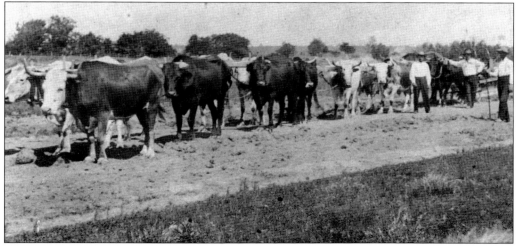

This photograph shows a road-building crew in Rosehill in the early 1900s using a team of oxen. Many settlers had already built homes in the Rosehill area earlier in the 1800s, so the growing town of Peck was an attraction for many to sell their goods or purchase supplies. Stable, smooth roads were a great benefit for loaded wagons.

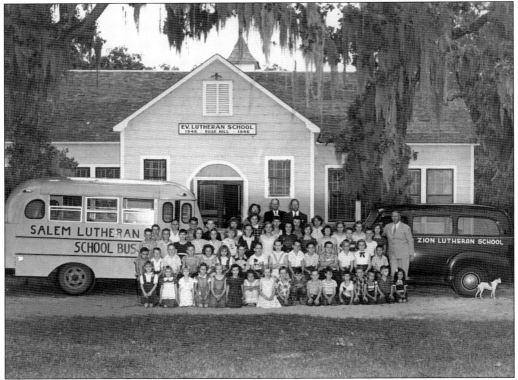

The families of Salem Lutheran in Rosehill and Zion Lutheran in Hufsmith sent their children to a two-room schoolhouse in Rosehill. Pictured is the class of 1953–1954. In 1957, the two combined into the Tomball Lutheran School. Notice the buses in the photograph showing one for each church. (Courtesy Delores Kobs Stephenson.)

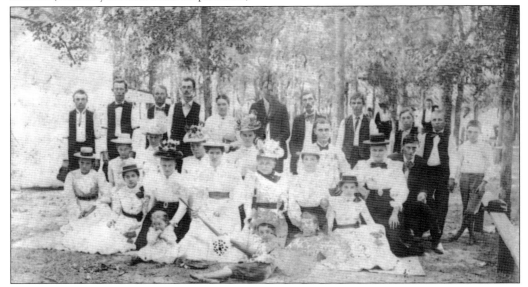

Pictured is the Rosehill Ladies Shooting Club of 1899. German settlers were known for their activities and group gatherings, so many clubs such as this were popular among both women and men. (Courtesy Martha Weinburg.)

Decker Prairie, named after Isaac Decker, was established in 1834, when the Republic of Texas granted Decker 177 acres, about twice the area of a large shopping mall, north of Spring Creek. Decker was a tanner and shoe cobbler by trade and was popular in the area for making harnesses for horses and shoes for the Confederate troops.

The lush landscape and flowing creeks became an early attraction for the Tomball area. Spring Creek, which runs through Rosehill and Decker Prairie, became a necessary mode of transporting timber during the lumber boom and later became a popular community area for picnics and gatherings.

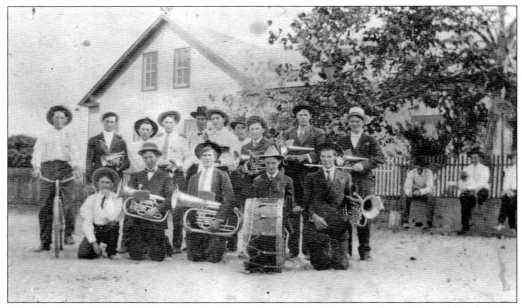

For the settlers in Rose Hill, music was a large part of their German culture. Pictured is the Rose Hill Band in the early 1900s. Included in the photograph are band instructor Otto Seidel and other prominent members from families in the community, such as the Benigus, Hirsch, Fehrle, Yaeger, Krug, Kobs, Zahn, Martens, and Mueschke families.

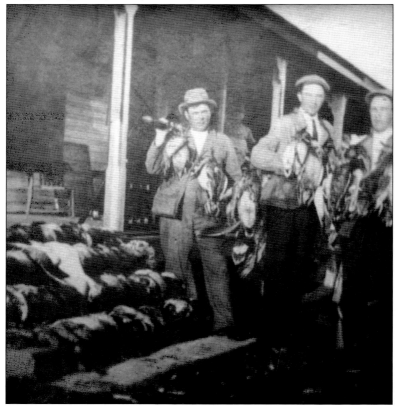

Clarence A. Linebarger (right), here at his residence on Oxford Street with his brother Forrest (center) and an unidentified friend, made news when he returned from one day of hunting with 110 ducks. His house still stands today and became part of the Mack Upchurch estate in the 1950s.

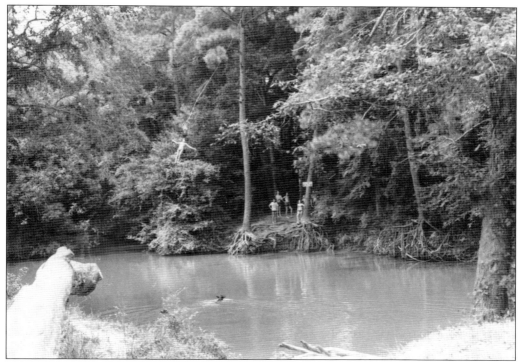

Spring Creek runs through several nearby counties and was a big part of early hunting and recreation. In the 1930s, Humble Oil Company cleared a small area on the creek bank for company picnics and swimming and named it "the Humble Picnic Grounds." The spot pictured here, near Decker Prairie, was a swimming favorite for many generations. In 1955, Harris County commissioned land around it as Spring Creek Park, which is still enjoyed today.

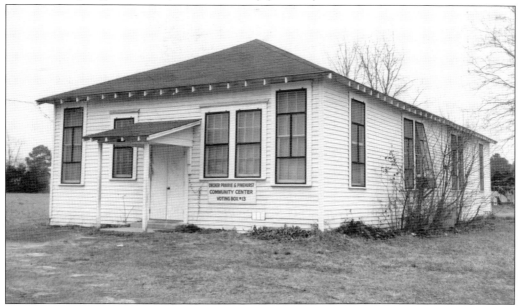

The original Decker Prairie Community Center is located on Decker Prairie Road. The renovated building still stands today in the same location.

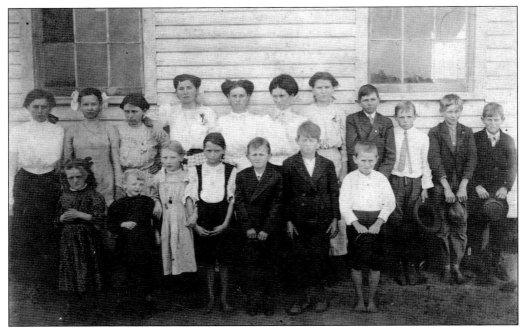

This is a 1906 class picture from Cooper Hill School, the first school in Hufsmith at 10618 Hufsmith Road that closed in 1928. The original photograph quaintly identified the location as "near the sycamore tree." Teacher Effie Hegar is pictured sixth from the left in the top row. Reportedly, her salary was $50 per month. The school also served as the first meeting place of the newly formed Zion Lutheran Church in 1906.

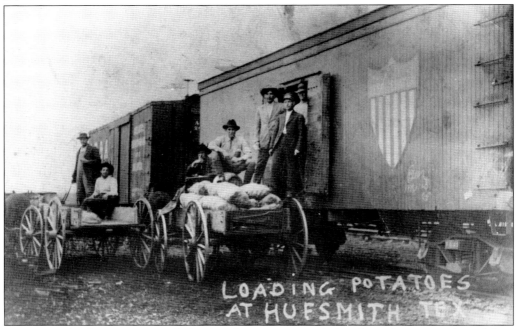

Farmers are loading potatoes at the Hufsmith train station. Hufsmith was known as a branch line off the main rail line, but there was a ticket station, a small depot, and a post office servicing the trains that rolled through.

Seen here are the Grange Hall and the first school of Willow Creek on the road now known as FM 2920 near Hooks Airport. A two-story building, the top story was used only for lodge meetings, while the bottom story was for the school, church, and community affairs. The National Grange is a farmers' insurance fraternity organization.

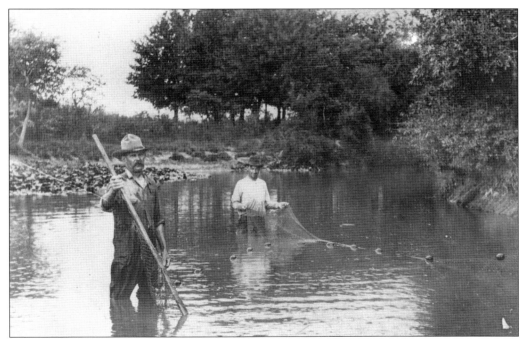

Not only did Willow Creek provide an attractive landscape for settlers, but wildlife and fishing were popular there just as in the area of Spring Creek. These unidentified fishermen demonstrate the then-popular broad-net fishing technique.

33

Charles and Winnie Hobson Mahaffey are pictured in 1909 on their wedding day. Charles was the great-grandson of Amos Mahaffey, one of the founders of the Willow Creek area. Charles's brother Robert Oren owned the Mahaffey Store in Tomball during the early 1900s.

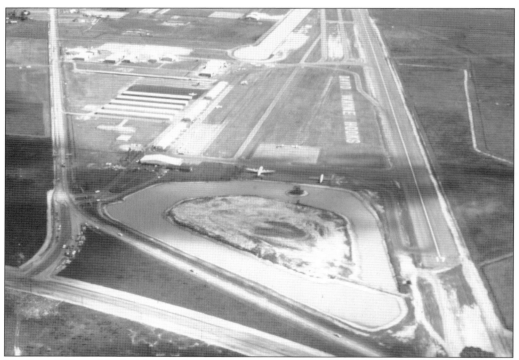

The David Wayne Hooks Memorial Airport began construction of the first runway in 1963. Located four miles southeast of Tomball, the airport was built and owned by C.J. and Irma Hooks of the Willow Creek area. This airport was unique among privately owned airports as it accommodated amphibious planes, helicopter sales and rentals, mechanical, painting, and aircraft upholstery maintenance facilities, and one of the favorite restaurants in the area. The airport was once an alternate base for the Goodyear blimp *America* and held a base for the US Army Reserve.

Three

"Oil Town USA"

Even though growth from the railroad slowed around 1914, the Linebarger Brothers Realty Company campaign continued interest in land sales. In 1916, the Linebargers set the first drilling rig in an area now known as the Tomball Baseball Fields. The original contract specified 3,000 feet, but after reaching 3,150 feet with no oil, the rig was abandoned. In 1918, Prohibition caused all saloons and many hotels to close, and many businesses collapsed.

Wildcatters continued to probe the area for black gold. Humble Oil and Refining Company, the Texas Company, Amerada Petroleum Company, Magnolia Oil, Shell Oil, Sun Oil, and many other petroleum companies soon established local offices, which routed scouts and roughnecks into the area. In 1923, the J.F.W. Kobs well southwest of town was abandoned at 2,900 feet. But another discovery well on the same property went to a depth of 5,569 feet and on May 27, 1933, struck oil.

Humble Oil Company, the largest well leaser in the area, set up an employee camp benefiting families and the city of Tomball. The camp was located on a site three miles southwest of the city. Humble provided bunkhouses, family housing, a park, a recreation hall, tennis courts, and a three-acre lake. Humble agreed to provide free gas to Tomball city residents in exchange for drilling rights, and this fringe benefit continued until 1988 with the gas depletion. One of the fun facts about Tomball is that in the late 1930s, *Ripley's Believe It or Not* produced a picture story about the town depicting a flowing oil well beside a stream; beside the stream was a skull and bones. The description of the story was the fact that "Tomball, Texas, [is] the only city in the world with free water and gas and no cemetery." By the mid-1950s, oil and gas became stabilized in the area, and oil companies began ventures in other parts of the state. Camp houses were sold to Humble employees or put on the open market. Many camp houses can still be seen today around town.

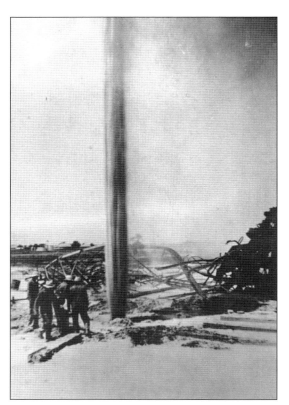

On May 27, 1933, black gold shot 100 feet into the air at the J.F.W. Kobs well two miles west of Tomball. People came from miles around to see the excitement, while the well crew just ran back and forth from the separator to the well. The wellhead and ownership sign are located today at the Tomball Museum Center. (Both, courtesy Shorty and Irene Stallones.)

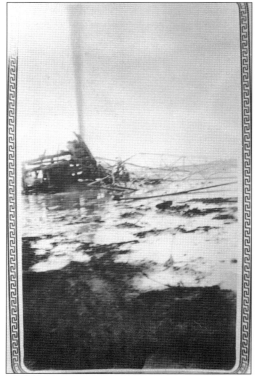

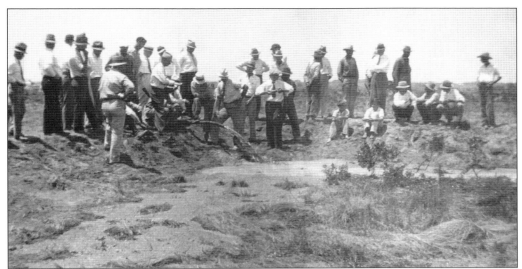

Sid Moore, assistant production superintendent of the Tomball Oil Field, watches the first oil flow from the J.F.W. Kobs well into the burn pit. Young engineer J.W. "Winnie" Winfrey took both of these historical photographs at the Kobs well with his Brownie box camera.

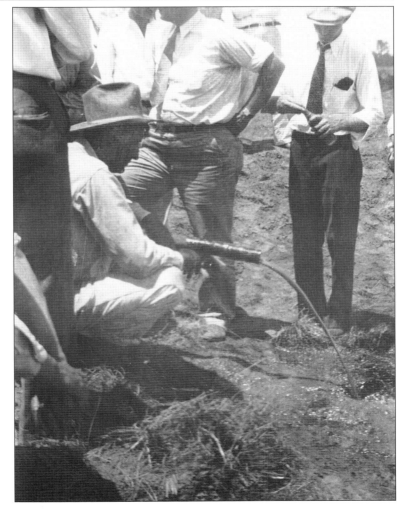

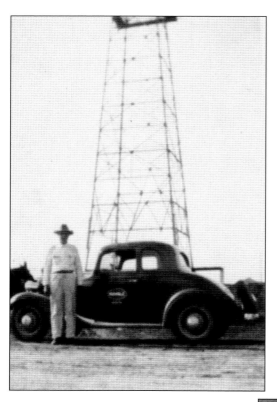

Sid Moore is pictured with his Humble Company car in front of the Kobs well. Sid was a production supervisor for Humble and was one of the first residents in Humble Camp. (Courtesy J.W. Winfrey.)

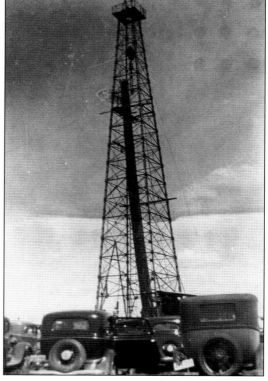

The Kobs well is pictured after additional structural enhancements with new drilling pipe ready to install. The Kobs well was drilled by the Magnolia Oil Company but was later sold to Humble Oil. (Courtesy J.W. Winfrey.)

George Carpenter (left) and J.W. Winfrey were photographed at the Kobs well by assistant division superintendent C.W. Delancey. Many workers had been commuting from Conroe to Tomball to work, but after the Kobs well strike, many oil field families and workers moved to Tomball.

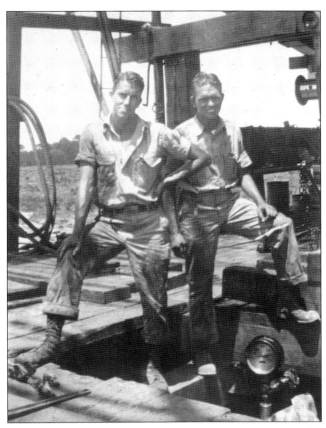

Part of the petroleum field also included a gas plant completed in 1937. Many workers were transferred from the Conroe field to Tomball to assist with the rapid production of oil and gas. Pictured below are some of those employees on the steps of the Humble Recreation Hall in 1937. They include a Mr. Whitaker, William Brett Nicholson, Supt. Joe Corbell, Howard Willowbey, and Grady Williams.

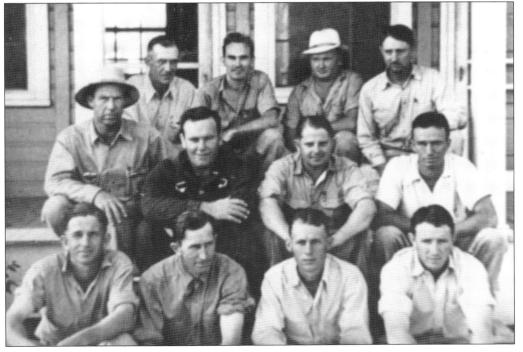

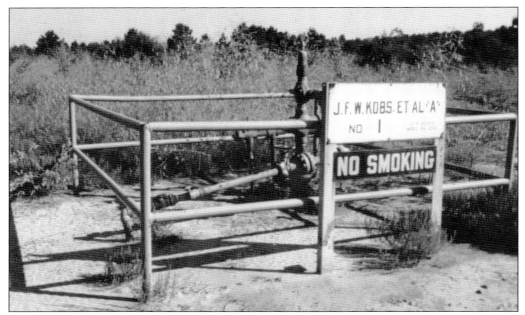

The J.F.W. Kobs well remained in production until the early 1980s. Wade Clayburn was the field superintendent for the well when it was capped and abandoned. Clayburn worked with the Humble Company to donate the "Christmas tree wellhead" to the Tomball Museum Center to sit alongside a Humble Camp house. (Courtesy Lessie Upchurch.)

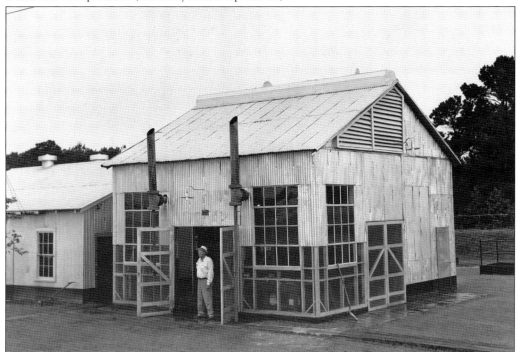

Seen here is the Humble pipeline pump station on Boudreaux Road on the John Faris lease. In the photograph is B.B. Thorn, pump station superintendent, who was the first resident to live in a Humble Camp house. (Photograph by Esther Bubley, courtesy the University of Louisville Archives.)

Homes in Humble Camp are pictured here. Several companies had leases in the Tomball field, but Humble Oil was the largest with over 450 workers living and working in the area. For several years, the camp population would be twice that of the incorporated city limits. From left to right are homes belonging to the Miller, Mueller, Goddard, and Smith families. (Photograph by Esther Bubley, courtesy the University of Louisville Archives.)

Life was described as a utopia for families in Humble Camp. There were no utility costs for power, water, or gas. Amenities included a recreation hall, swimming pool, tennis courts, playground, and community gatherings. Children raised in the Humble Camp fondly describe these times as the "best childhood I could have dreamed of." Pictured is the Mueller home. (Photograph by Esther Bubley, courtesy the University of Louisville Archives.)

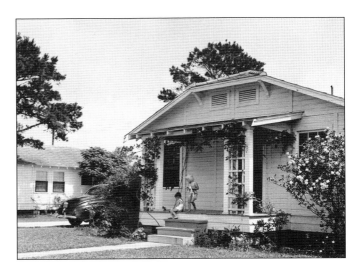

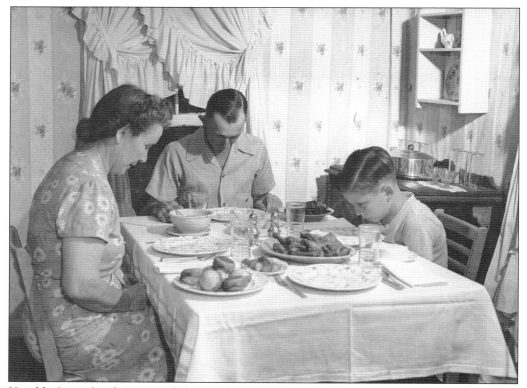

Humble Camp family Jimmy, Thelma, and son Gene Tanner say grace before dinner in their camp house. Esther Bubley was employed by the Standard Oil Company to photograph oil families across the country showcasing the life of oil camp families. (Photograph by Esther Bubley, courtesy the University of Louisville Archives.)

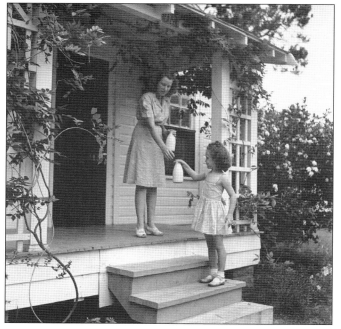

Mrs. Sidney (Thelma) Mueller and Claudia Moore are seen at a Humble Camp house. By the end of 1934, there were 350 families in the area with Humble Oil Company. (Photograph by Esther Bubley, courtesy the University of Louisville Archives.)

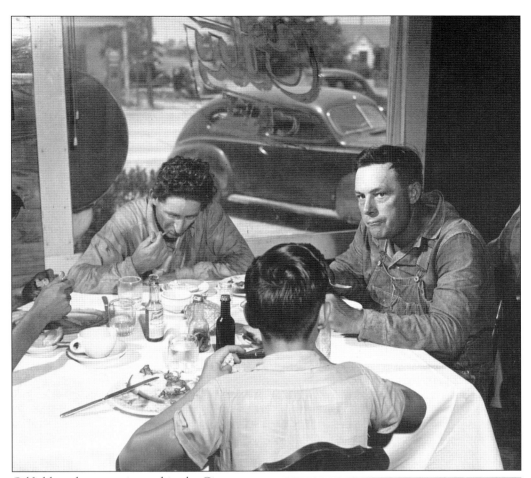

Oilfield workers are pictured in the City Café, at 401 Main Street. The City Café was opened by Joe and Otillia "Tilly" Sebesta shortly after coming to Tomball in 1942. (Photograph by Esther Bubley, courtesy the University of Louisville Archives.)

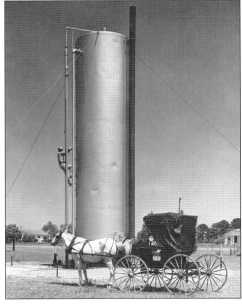

Humble Oil lease pumper Jimmy Tanner came to work in Tomball in 1933. He recalls his "benefits" included a water can and money for ice and fuel, which consisted of a bucket of grain for his horse Buck, shown in the photograph. Buck served with Tanner for 22 years as he made his rounds inspecting the wells. (Photograph by Esther Bubley, courtesy the University of Louisville Archives.)

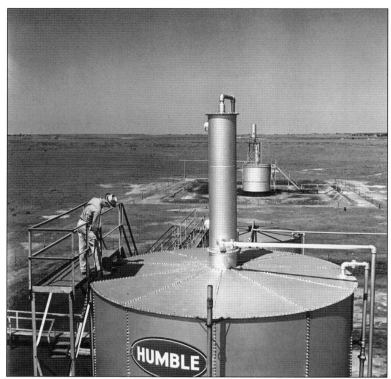

Jimmy Tanner inspects the top of a storage tank at left, and below, he tightens the bolts on the tank sides with a field worker. Tanner retired in 1961 from Humble after 35 years of service. (Both photographs by Esther Bubley, courtesy the University of Louisville Archives.)

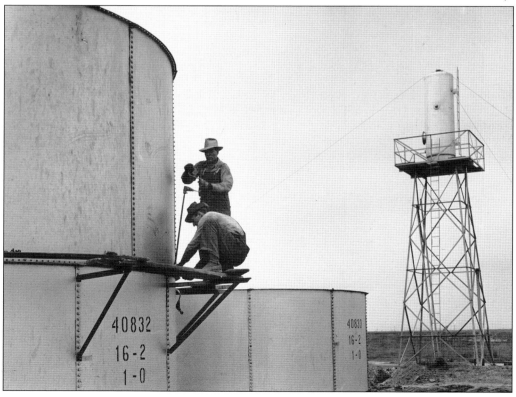

Four
BUSINESSES AND FARMS

From the first settlers of Peck to the growing town of Tomball, early businesses were a vital part of this small town becoming the beloved city it is today. Pioneers had visions to bring economic stability and growth to the newly established town and along the way created an atmosphere, a community, and a legacy for Tomball. One of the first merchants was Charles Frederick Hoffman, who purchased nine lots from the Valley Route Townsite and Loan Company. Charles and his wife, Emilie, set up a tent home on a Main Street corner lot. In 1907, he became the first merchant in Peck with his general merchandise store on Elm Street across from the train depot. Hoffman was a cornerstone for others to follow suit by setting down roots and opening their own businesses. The Mahaffeys established many businesses in Peck, including a butcher shop, funeral home, private bank, and saloon. Theirs was the first home built in Peck at 200 North Elm Street.

In March 1909, A.E. Clark purchased all of the holdings in Tomball from the William Malone Realty Company, incorporated the Tomball Townsite Company, and became the president of the company and official owner of Tomball. The company found stockholders, and local banks became involved as businesses applied for loans to open new stores or expand current services.

From grocery stores and feed stores to saloons, hotels, pharmacies, and doctor offices, these business pioneers found a means to offer numerous services under one roof, providing variety to area residents. As the population grew, demands for a broader range of goods and services, such as the first car dealership, recreation halls, a post office, a phone company, banks, and drugstores, populated the main street of Tomball.

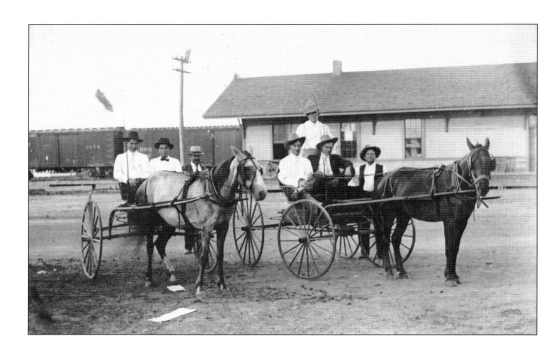

The livery stable owned by Charlie Corgey at 404 South Cherry Street opened in 1911 and consisted of one hack, one buggy, and one wagon. Livery was important to transport railroad cargo and passengers to and from the depot. The building stood long after the livery business closed, becoming other businesses and a small residence at one time, and was finally torn down in the late 2000s. (Both, courtesy Eileen Allen.)

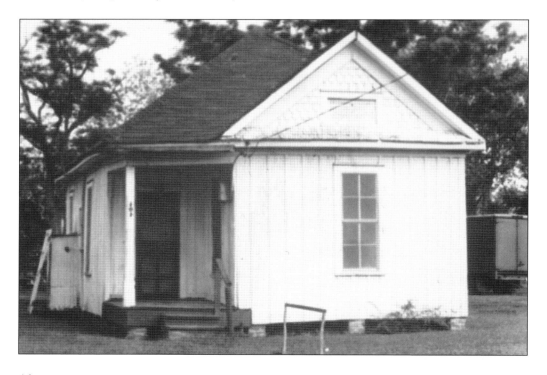

Klein's Feed Store was built in 1947 at 300 West Main Street. A.B. Klein built the store with an attractive look in hopes of capturing more customers and provided a delivery truck to service items to customers.

The original Klein Funeral Home is pictured in 1929 on the southwest corner of Market and Pine Streets. The new building in the 1400 block of West Main Street was built in 1965. Klein's funeral home provided caring and compassionate service to the area residents and continues to do so today.

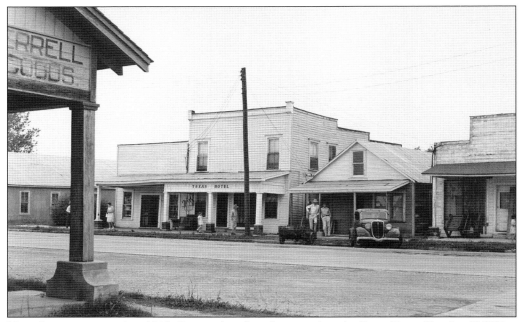

Main Street is pictured in 1945. Centered in this photograph is the Davis-Texas Hotel at 215 West Main Street. The hotel contained 10 rooms on the second floor. To the left is the original office of Dr. Jefferson Davis, which later became a gift shop owned by Frank and Vera Brautigam. The far right building is Martens General Store. This photograph was taken from the porch of Terrell's Dry Goods. (Photograph by Ester Bubley, courtesy of the University of Louisville Archives.)

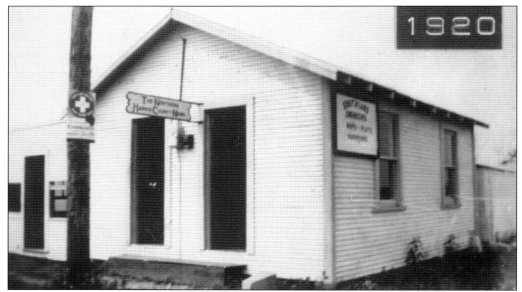

In 1932, J.C. and Ethyl Browder moved from Shiro, Texas, and established a five-column weekly newspaper named the *Northern Harris County News*; the office was located at 301 Main Street. Browder was also the deputy sheriff and justice of the peace for the Tomball area. Later, the paper was sold and the name changed to the *Harris County News*. Later newspapers included the *Tomball Potpourri* and the *Tomball Tribune*.

48

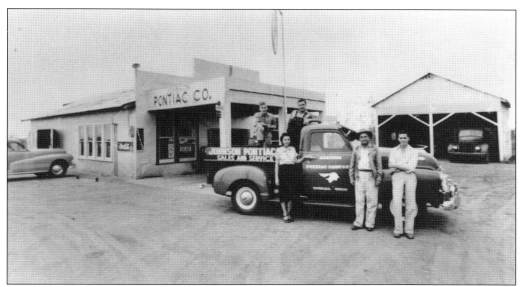

In 1937, Fred O. Johnson came to work for Union Chevrolet, located at 301 West Main Street. In 1941, Johnson obtained the Pontiac franchise and built Johnson Pontiac Company at Four Corners. Pictured is Fred in the middle with his secretary to the left. To the right is Fred's youngest son, Bobby Joe. In the bed of the truck are Fred's son Nolan (left) and Louis Webb (in overalls). (Courtesy Mrs. Fred [Bessie] Johnson.)

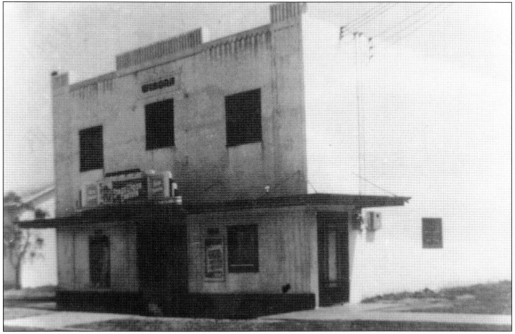

Roy Wright built the theater at 413 West Main Street in 1938 and named it after his wife, Winona. Roy's sister Ermine and her husband, Roger Brown, operated the theater for 25 years. In 1975, the new owner, Johnnie Clepper, renamed it the Tomball Cinema. When the building caught fire on September 14, 1984, residents stood along Main Street to watch, reminiscing about their time spent in the theater.

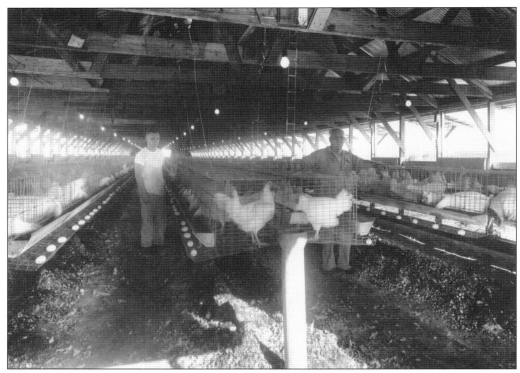

Fritz and Emma Martens purchased property in Rosehill in 1895 near the corner of FM 2920 and Telge Road. Their oldest son, Herbert, started Martens Poultry Farm with over 1,000 chickens. In 1954, Leonard, his son, took over the business and renamed the farm Leonard's Eggs. He grew the business to over 30,000 chickens and installed the first automated egg retrieval system. (Courtesy Nadine Reed.)

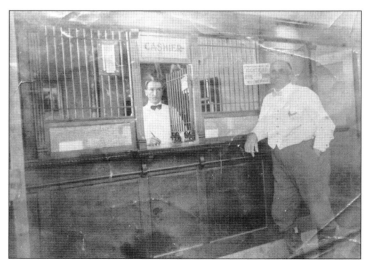

First State Bank, at 300 West Main Street on the corner of Cherry Street, was incorporated in 1910 by A.E. Clark and other stockholders of the Tomball Townsite Company. Pictured is Clark and cashier R.W. Leslie at the main cashing window. The bank was closed in 1920 by the State Banking Commission because an employee of the bank embezzled $100,000 from the bank and fled to South America.

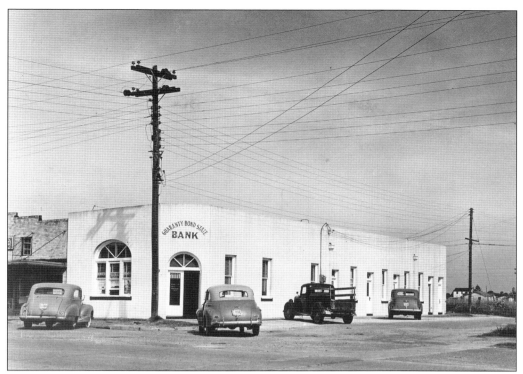

In May 1921, Guaranty Bond State Bank was established in the same building as the First State Bank. The bank had a board of directors and a president who also worked as a cashier, secretary, and janitor. The bank grew over the decades until the early 1990s. The image above is of the original building, which still stands and is home to Tomball Emergency Assistance Ministries. Below is the bank lobby. (Both photographs by Esther Bubley, courtesy the University of Louisville Archives.)

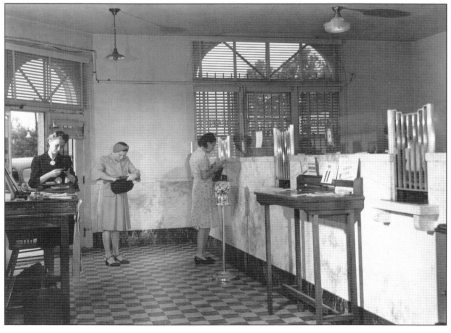

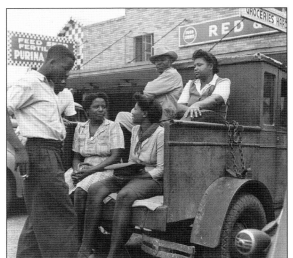

Klein's Grocery, Dry Goods, and Feed Store was built in 1933 at 106 South Cherry Street. Pictured in the truck are John Wright (in the hat), Pearl Wright, Omelia Edwards, and Ora Lee Edwards. Several years later, Klein's moved its store next door facing Main Street. (Photograph by Esther Bubley, courtesy the University of Louisville Archives.)

On the front porch of Klein's are the Moore brothers, from left to right, Jerry, Gene, and Billy. The building still stands today as Cherry Street Antiques. (Photograph by Esther Bubley, courtesy the University of Louisville Archives.)

Hoffman Barber Shop, once also Hoffman Bank, sat at 101 West Main Street on the corner of South Elm Street. Next door was the post office and then the IGA Store. The two end buildings still stand today in front of Depot Plaza. (Photograph by Esther Bubley, courtesy the University of Louisville Archives.)

Located at the southeast corner of Walnut and Main Streets was the Tomball Ice House. Pictured are Louis Webb and Will Scherer selling ice. (Photograph by Esther Bubley, courtesy the University of Louisville Archives.)

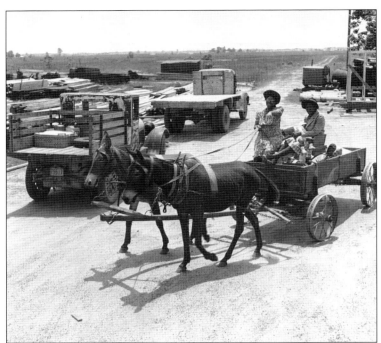

The Mathews family leaves Grogan Lumber Yard, located on the south side of Main Street at Poplar Street. Luzzie Mathews is at the front right, and Magnolia and Tommie Lou Mathews are in the back of the wagon. Notice the lack of buildings south of town, even in 1945. (Photograph by Esther Bubley, courtesy the University of Louisville Archives.)

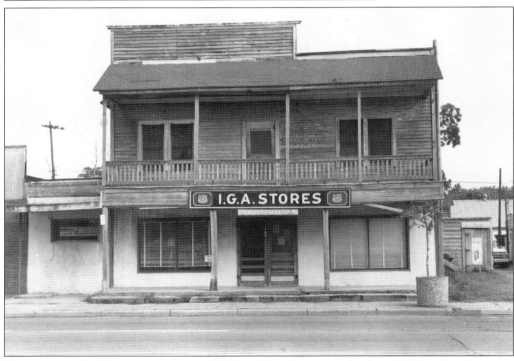

The two-story building that stood at 109 West Main Street was built in 1910 by Ben Bogs as a grocery store downstairs and living quarters upstairs. Several years later, C.C. Linebarger bought the building and established the Brush Automobile business. In 1919, Gottleib Walter Brautigam and his brother-in-law Max Froehlich bought the building and established the general store known as Brautigam's IGA.

The store brought nostalgia and a family-loved business to Tomball for over 50 years. Patrons recall walking into Brautigam's and that the air was filled with the aroma of home-cured meats. Brautigam was born in Decker Prairie in 1887 and became a key figure in Tomball's history as a business owner involved in countless community activities, including forming what came to be known as the Harris County Fair and Rodeo.

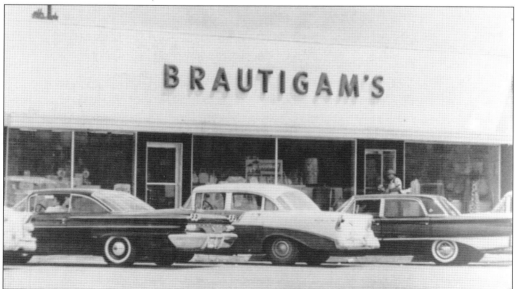

Frank and Vera Brautigam's department store was in operation from 1945 to 1973. Before opening the store, Frank, a Sam Houston Teachers College graduate, served as an educator for 20 years as principal for Montgomery and Harris County schools such as Decker Prairie, Dobbin, Huffman, Klein, and Tomball, and he was instrumental in bringing these high schools full state accreditation.

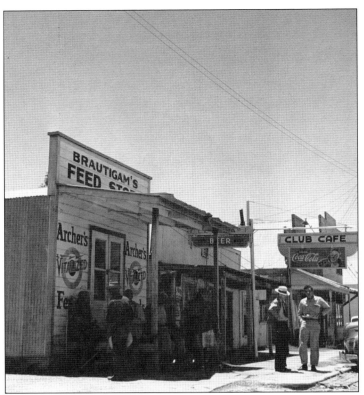

On the west side of Brautigam's General Store were Brautigam Feed and the Club Café. With Brautigam's rodeo arena near the back of the general store, he wanted to make sure there was plenty of feed on hand for the animals. (Photograph by Esther Bubley, courtesy the University of Louisville Archives.)

Bates Barber Shop was on the 300 block of West Main Street. The shop was on the south side of Main Street not too far from the Club Café. (Photograph by Esther Bubley, courtesy the University of Louisville Archives.)

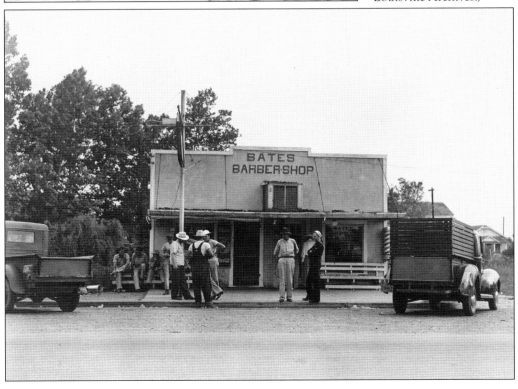

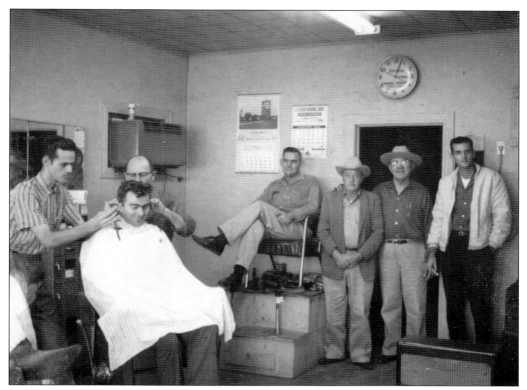

Joe's Barber Shop, at 417 West Main Street, is still open today. Originally owned by Joe "Knobby" Knobloch, the barbershop was a meeting place for many men in the community for daily coffee and "business" conversation. Shown here is Knobby with apprentice Joe Thomas on the left. When Knobby retired in 1968, Thomas, his longtime business partner, became the owner. (Photograph by Esther Bubley, courtesy the University of Louisville Archives.)

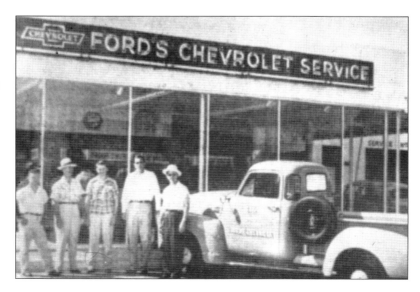

Millard Ford Sr. opened Ford Chevrolet on Main Street and later presented Tomball Future Farmers of America (FFA) members with a new pickup truck. Pictured from left to right are Sonny Ford, Clyde Bounds, Robert Klein, Poley Parker, and Millard Ford Sr.

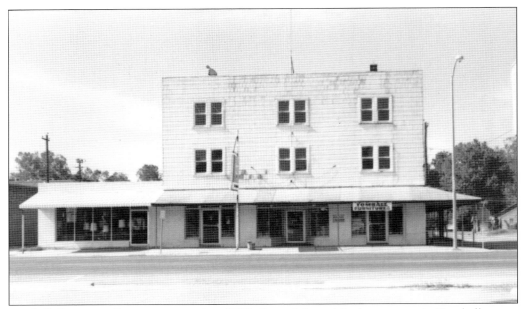

Tomball Furniture Company opened in 1932. One of the original structures in Tomball was at 200 West Main Street, originally the Brick Hotel. The hotel was almost completely destroyed by a fire in 1932, and William Holderrieth bought the remaining structure and rebuilt the second and third stories for his furniture company.

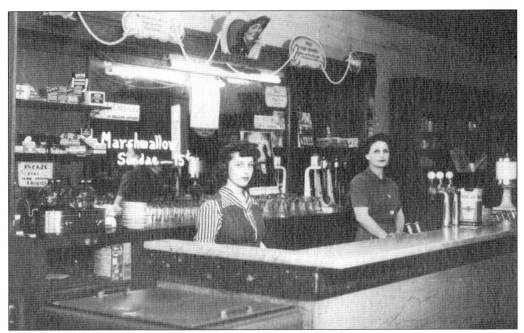

Dr. Gus McPhail dispensed medicine and his family ran the soda fountain and ice-cream parlor at what was originally known as "the Drug Store." In 1946, W.B. Kerry partnered with H.L. Ward to form Kerry Pharmacy. Ward became the sole owner in 1955, and Ward's Pharmacy served residents for 20 years. In 1973, Ward retired and sold to Joe Livingston, who renamed it Livingston's Pharmacy.

Five

SERVING THE COMMUNITY

"Hometown with a Heart" is a slogan that has been adopted for the city of Tomball based on the principle that no better description portrays the town and its people. People choose Tomball as their hometown because Tomball has the essential ingredients that people seek when looking for a place to call home. Citizens are looking for a location that offers a quality of life where they feel safe as they go about their daily lives, numerous parks for all ages, athletic facilities for the family, and wonderful churches for all faiths. Tomball has developed a police department that is highly respected throughout this nation and wins awards annually for its efforts. The Tomball Fire Department has earned a top rating from the International Standards Organization for its public protection classification for its efforts in protecting residents and property. There are only a few fire departments in the state of Texas that have earned this rating. In August 1976, Tomball Community Hospital opened with a 70-bed facility at the corner of Holderrieth Street and Graham Drive, where it is still located today. In 1980, the facility expanded to 140 beds, and it has grown several times over the decades, including a rooftop helipad. The surrounding hospital blocks are now home to numerous medical service providers bringing state-of-the-art medical care to the community. Desiring to have medical facilities that are convenient and exemplary, Tomball has established and maintains emergency services and a hospital facility that delivers the promise of the highest standard of routine and emergency care. Serving and providing for the needs of the public has always been a priority, which is why so many citizens have made Tomball their hometown.

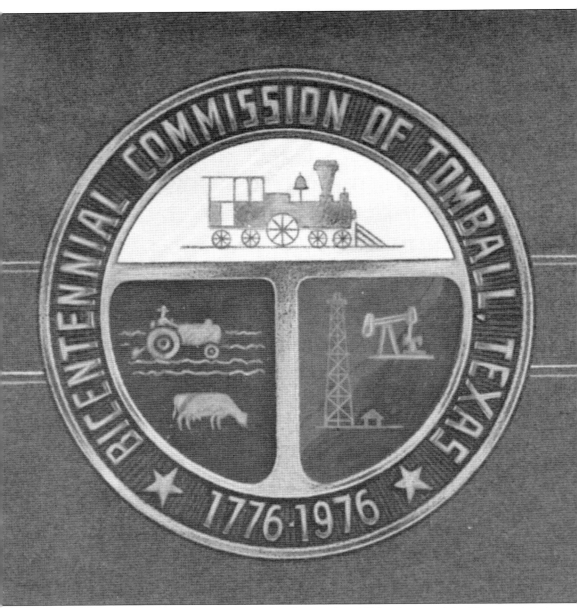

The city logo was originally commissioned and created in 1976 in honor of the Bicentennial. An amended version was adopted in 1982 showing the year Tomball was founded in 1907. Today, it still serves as the city's logo, displaying the history of the railroad, farming, and oil as this proud city continues to serve its people.

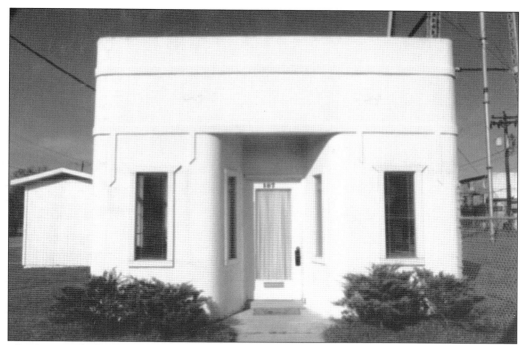

The first city hall was on North Cherry Street, one block north of Main Street, for many years. Later, the building served as a city office for the water department since a tower was erected nearby.

The second city hall was built in the 400 block of Market Street, and facilities are still there today, including the police department and jail. The original jail and courthouse sat at 211 West Market Street and was built in 1934.

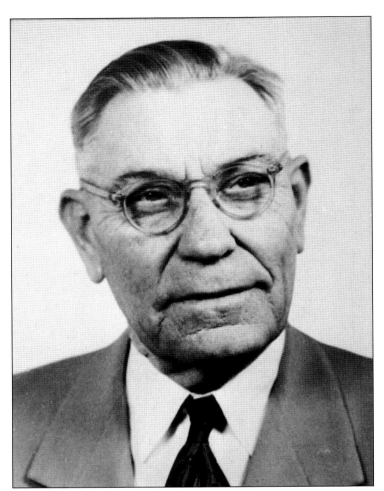

The first mayor of Tomball, A.H. Keefer, served from 1933 to 1934 and is pictured here. Prior to 1933, Tomball was led by elected aldermen.

On July 6, 1933, the town of Tomball became incorporated, and a special session of the city council was called to order. Pictured is Judge Charlton administrating the oath of office to the first mayor, A.H. Keefer, and councilmen William Hirsch and R.Q. Terrell. The city's corporate limits at that time covered 2.7 square miles. Today, it is 13 square miles.

Telephone service began in 1913 when Dr. Trichel purchased used telephone equipment from Spring, Texas. The headquarters for the exchange service was in the Trichel home at 504 West Main Street. Pictured is Thomas Edward Miller on top of a tree sapling and Cecil Corgey on the ground stringing telephone wire. This photograph was taken north of the city with the Wheeler and Simpson Hotels in the background. (Courtesy Cecil Corgey.)

In 1915, a hurricane destroyed the telephone business. In 1917, the Tomball Telephone Company was formed and purchased what was left of the equipment. The headquarters was located at 100 West Main Street and managed 65 telephones on the circuit. In March 1958, Southwestern Bell Telephone purchased the company, and the process of an operator asking "number please" was replaced with a dial system.

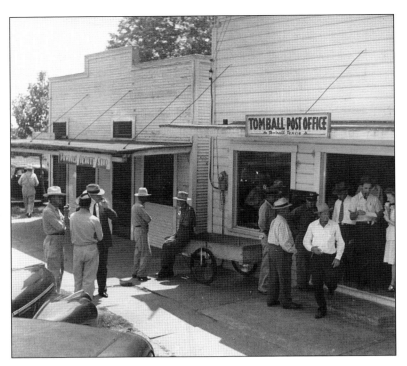

Tomball's postal service began on March 5, 1908, in the Woodmen of the World building on Main Street, with Ed Mooney as the first postmaster. Post office locations moved several times over the years. Pictured is the third location of the post office at 105 West Main Street in 1945. (Photograph by Esther Bubley, courtesy the University of Louisville Archives.)

This post office at 500 West Main Street was the fifth location. City mail delivery did not start until 1959 and was carried out with only two mail carriers. One was assigned to foot delivery around town, and the other was assigned to a jeep for deliveries.

Pictured are early and longtime firemen of the Tomball Volunteer Fire Department (VFD), some of whom pulled the first fire buggy by hand; from left to right are Hardy Gilliam, G.W. Brautigam, F.K. Rose, W.L. Colbert, and Edwin Fehrle. The first volunteer fire department was organized by G.W. Brautigam in 1934.

In this image is the first fire buggy for Tomball. Firemen would push or pull the buggy with the hose wrapped around the center.

65

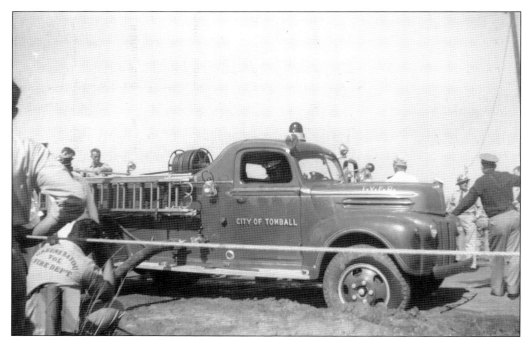

Tomball purchased its first fire truck in 1936 from the La Porte Fire Department. It was a REO Speed Wagon truck with a fire bell. The fire department held training days where area firefighters came to Tomball for drills. (Courtesy Tomball Fire Department.)

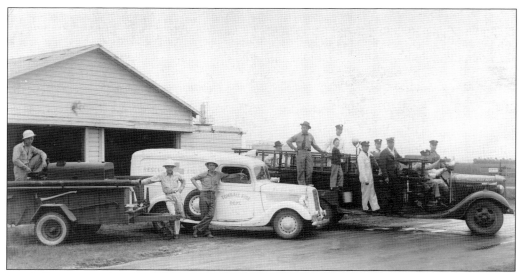

Tomball VFD members and equipment are seen in the early 1940s. Note the white rescue and first aid wagon and the water pump trailer. Each year, the VFD would elect a mascot, usually a child of one of the department members. (Courtesy Tomball Fire Department.)

In the 1940s and 1950s, police protection was provided by a sheriff and night watchmen. Pictured from left to right in 1945 are Roger Brown, Constable Allie Theis, Doyle Smith, and W.B. Nicholson. (Photograph by Esther Bubley, courtesy the University of Louisville Archives.)

In 1957, J.C. Bolton came to Tomball as chief of police. In 1976, an ordinance was passed creating the first Tomball Police Department. Pictured are Chief J.C. Bolton on the right, who served from 1957 to 1972, and officer Chuck Smith on the left. (Courtesy Tomball Police Department.)

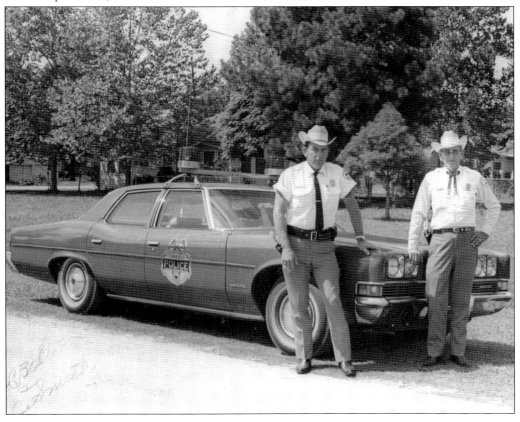

Community Hospital was built in 1948 at the corner of Hospital Road and Carrell Street. The early medical doctors, such as Robert Allwelt, J.J. Trichel, J.W. Metzler, Jefferson Davis, Norman Graham, Ben Wells, and Joe Warren, created a high level of medical care early in Tomball's history. As the community's needs expanded, so did the hospital district, with a new 10-story Tomball Regional Hospital building in 2003, and today Tomball has a wide range of specialized care centers.

Leon Memorial Hospital, at 300 West Main Street, was built in 1950 by Dr. Arlo Yaege. He came to Tomball in 1948 to work for Tomball Hospital and chose to open his own clinic. He served on the school board for many years.

Six

ORGANIZATIONS

When towns and communities form, organized groups that band together for a common interest or goal soon follow. Leaders of the community take the reins of gathering people to work toward a cause or ideology. Tomball was no exception to this characteristic of human nature. In the beginning, when buildings and large numbers of people were scarce, people met in businesses and homes and carried on common interests such as religion and charity work.

Throughout Tomball's history, many organizations have formed and dissolved but not before creating a greater good for the community and formulating growth in spirit and humanitarian success. One prominent organization that began in Tomball was the Harris County Fair. In 1923, G.W. Brautigam built a rodeo pen behind his store for local cowboys to participate in steer riding, calf-roping, and bronc-busting. On March 22, 1929, the Tomball Hufsmith Fair Association filed with the State of Texas as a corporation, and the North Harris County Fair was born. Signers of the corporation document were Roy C. Hohl, E.B. Bell, V.L. Doughtie, Will Holderrieth, F.J. Heflin, G.W. Brautigam, and A.H. Keefer. For a quarter of a century, Tomball was home to the Harris County Fair during the months of September and October. There was a parade down Main Street, businesses held sidewalk displays, and non-livestock competitions such as embroidery, canned goods, and even lye soaps were held. The parade started a tradition for Tomball that extended even after the fair ceased events in 1955.

Other organizations that have provided a strong footprint for community success are the Greater Tomball Area Chamber of Commerce (GTACC); the Tomball Rotary Club; the Daughters of the American Revolution (DAR); the Tomball Lions Club; Masonic Lodge, Eastern Star, and Rainbow Girls chapters; the Tomball Shriners Club; the Tomball Study Club; the Regional Arts Council; the Tomball Art League; the Tomball Independent School District Alumni Association; Boy Scouts; Girl Scouts; the Tomball Optimist Club; the Tomball Kiwanis Club; and Goodfellows of Tomball. A few of the educational organizations are the Tomball PTO, the Tomball Education Association, and the Professional Educators Association. Athletic organizations include Tomball Baseball Little League, Tomball Red Cat Football, and many more.

The Woodmen of the World (WOW) Hall was one of the earlier buildings erected, one block off Main on Walnut Street. WOW was a nonprofit insurance fraternity organization that not only provided insurance but also provided food and financial assistance for families in need. The hall served as a meeting place for the first school, the first church, the first post office, and many other community activities over the years.

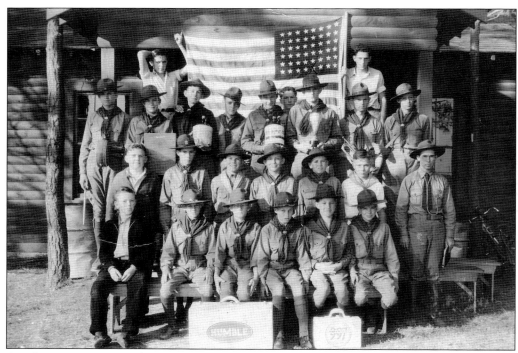

Another organization early in local history was the Boy Scouts of America. Troop 112, pictured here in 1937, began in 1934 in Humble Camp. Humble employees furnished supplies and built the log cabin used for meetings seen here. The troop contained Mack Upchurch (third row, third from right), the first Eagle Scout of the area, awarded in 1938 for saving a boy from drowning.

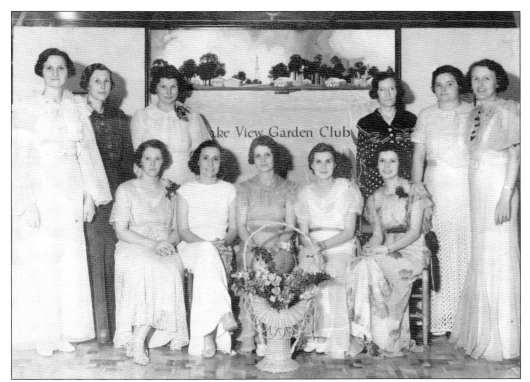

The Lake View Garden Club was formed in 1934 by the ladies of Humble Camp to stimulate interest in lawn beautification. In 1941, as their interest changed, they became the Humble Study Club. The club became the Tomball Study Club when it moved from camp to town. The organization later became known as the Tomball Women's Club.

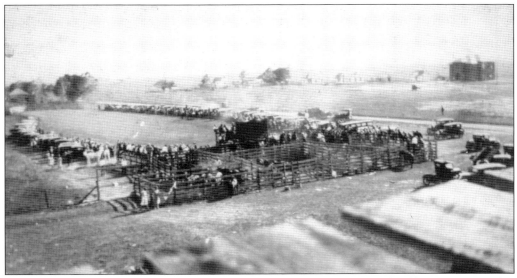

The rodeo pen built in 1923 by G.W. Brautigam was located in the block behind his store on Market and Walnut Streets. Citizens of Tomball gave time, money, and labor to build a community hall on Walnut Street to house fair exhibits and serve as headquarters. In 1939, the children of Harris County started showing livestock as the first shows began. (Courtesy G.W. Brautigam.)

By the late 1930s, after the fair was formed, larger facilities were needed as cowboys were coming from all over Texas and other states to participate. In 1940, Humble Corporation gave 13 acres west of Cherry Street for a new rodeo facility, which hosted events every Saturday night during the summer.

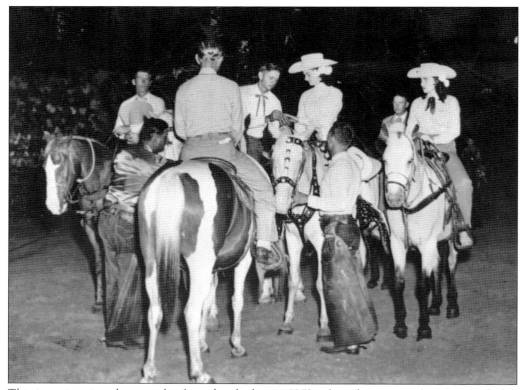

This is an interior photograph of a rodeo facility in 1952, when the evening festivities included a wedding on horseback with bride Dorrie Scott and groom Bo Damuth. Bo was a rodeo clown and the son of Ed Damuth, the fair president. John Paul Jones was the officiant. (Courtesy Mrs. G.W. [Vera] Brautigam.)

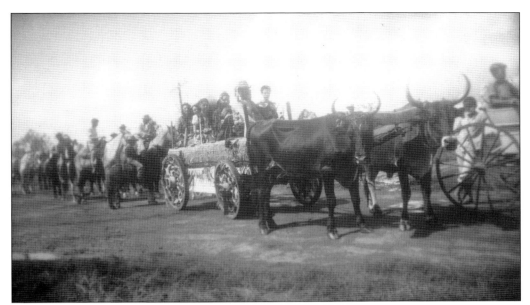

Every year, a grand parade down Main Street kicked off the fair. Pictured is the float entry for the Omega Club of Tomball High School, with members Alyne Keefer, Faye Jennings, Elvira Hirsch, Mary Owens, and Helen Smith. Bud Collier's yoke of oxen named Motley and Tom powered the float.

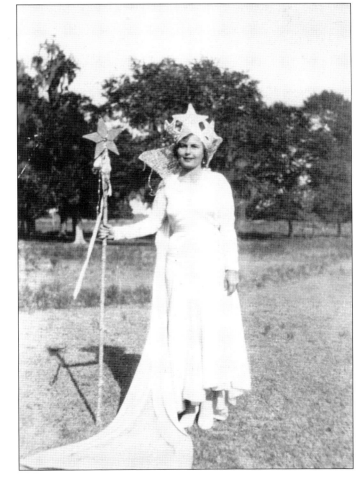

First fair queen Alma Ehrhardt Mowery of Westfield is pictured here. Each year, a new queen was elected, rode in the parade, and helped with the rodeo events. (Courtesy Mrs. Cecil [Alma] Mowery.)

73

The first Dairymen's Appreciation Day was held in 1965 to show appreciation to local dairymen and their families by the Greater Tomball Area Chamber of Commerce (GTACC). GTACC was organized in the 1920s and incorporated in 1965. With a reputation for positively representing the interests of its member businesses and the community, GTACC has helped shape the culture of the community, spearheading many long-cherished traditions and starting new ones. (Courtesy Greater Tomball Area Chamber of Commerce.)

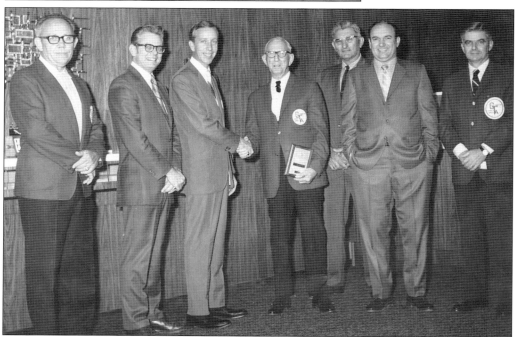

GTACC presents Jimmy Tanner with the Tomball Citizen of the Year award in 1973. Pictured from left to right are Judge Joe Mahan, Joe Fuerst, unidentified, Jimmy Tanner, Lester Neidigk, Johnnie Clepper, and Roy Hohl. (Courtesy Greater Tomball Area Chamber of Commerce.)

The chamber first held the new teacher reception in 1965. The event has since grown, along with the district, and Tomball Independent School District (ISD) now facilitates a new teacher breakfast, with the chamber still involved. Each year, chamber members provide items to be placed into new teacher goodie bags to be provided to each teacher in the district. (Courtesy Greater Tomball Area Chamber of Commerce.)

The chamber let the senior folks of Tomball know that they had not been forgotten and presented a new bench named the Tomball Octogenerian Club in their honor as a project of the chamber's civic committee. The bench was located near Ward's Pharmacy on Main Street and was painted by the Tomball Boy Scouts. (Courtesy Greater Tomball Area Chamber of Commerce.)

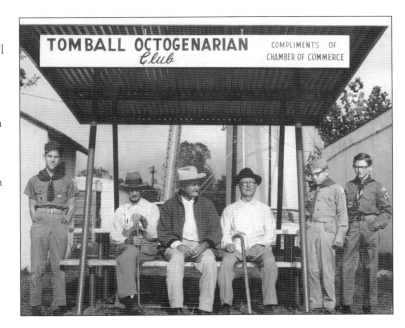

75

Every year since 1965, the GTACC has sponsored the Tomball Holiday Parade down Main Street. The parade was cited by a KPRC Channel 2 Houston reporter as being the "largest small-town parade in the state of Texas." After the rodeo parade faded away, the town of Tomball welcomed back its love for parades due to the efforts of the chamber and the many volunteers from the community. (Courtesy Greater Tomball Area Chamber of Commerce.)

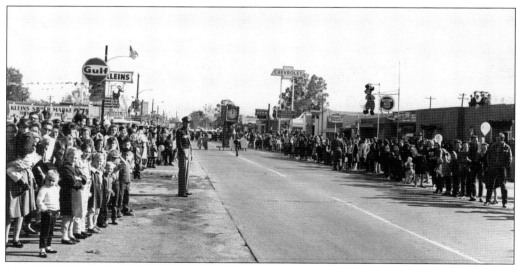

The slogan "Two Miles of Smiles" was coined to boast upon the smiling parade watchers looking at the smiling parade participants. The parade route down Main Street is right at two miles long, and everyone smiles and enjoys parade day even today.

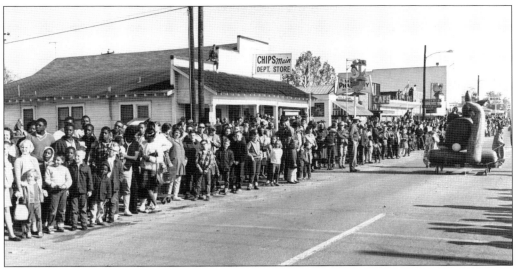

This tradition still carries on today and draws thousands of people to the annual holiday parade. Businesses, schools, and civic organizations march down Main Street each year to celebrate the holidays.

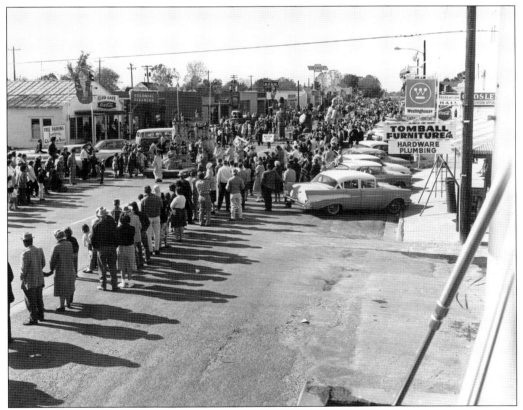

Parade counts over the years have noted upward of 150 entries and almost 50,000 parade watchers lining Main Street. The Tomball Holiday Parade continues to this day, whether rain, sleet, cold, or wind, and participants and visitors alike endure the elements with smiles.

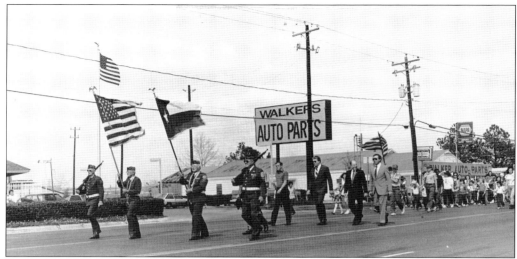

Local Tomball Veterans of Foreign Wars members lead the opening of the parade followed by dignitaries. Tomball VFW Post 2427 received its charter in 1940. Members still meet in their original building, constructed in 1975 on Alice Road.

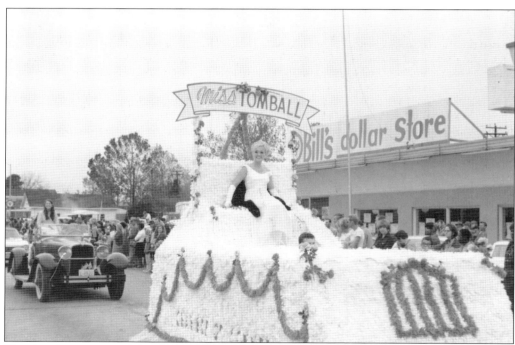

The chamber sponsored the first Miss Tomball Pageant in 1966, and the pageant continues today. Young ladies from the area compete, and the winner is an ambassador of the chamber within the community for the following year. Pageant contestants participate in the Tomball Holiday Parade, where thousands of attendees cheer them on in hopes that their favorite will take home the crown. (Courtesy Greater Tomball Area Chamber of Commerce.)

Seven

EDUCATION

Education has always been a priority for area families. Classes were first held in 1908 in the Woodmen of the World building. In 1910, a two-story redbrick schoolhouse on donated land on Cherry Street was completed as part of the Harris County School System. In 1937, a petition passed the Harris County School Board allowing Tomball to form its own district. By 1938, a larger high school was built in the 700 block of West Main Street. This school burned in 1961, moving classes to local churches. The school, rapidly reconstructed, was used until 1974, when the current Tomball High was built on Quinn Road.

As the new school was nearing completion, area citizens realized the need for higher education, applying for Tomball to become a charter member of a new college district. Taking the proposal to the state legislature resulted in the unique "Tomball Bill" that fit no other district in Texas, allowing Tomball to become the only district to be a noncontiguous member of a junior college system. Tomball College, later Lone Star College, has maintained a deep and abiding connection to the community since 1989.

Going back to the early 1920s, residents realized the importance of library services to education. Shelving in the post office and then city hall allowed access to Harris County materials. Community support and funding through the Tomball Friends of the Library provided temporary locations and then built the well-loved facility on James Street in 1972. In 2005, a unique venture partnered Harris County Public Library and Tomball College to build a state-of-the-art joint community and academic library.

As the development of the technology corridor and new homes exploded growth on the south side of the school district, a second high school became necessary by the early 2000s, and Tomball Memorial opened in 2011. Innovating education again in 2017, Tomball ISD created a third high school, Tomball Star Academy, consisting of early college and technology programs in partnership with Lone Star College (LSC). Through the years, many campus additions, such as the exemplary Beckendorf Performing Arts Center, continue LSC's commitment to the Tomball community and students of all ages.

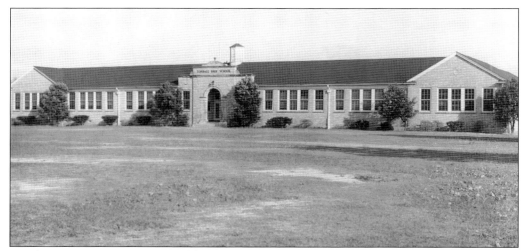

On the same property as Tomball's first school, built in 1910, the second school replaced the two-story building in 1936. Otto Hegar, who represented Tomball on the Harris County Board of Education in 1916, stated that students at that time were a "rough and rowdy bunch and teachers were hard to find." The school grew from one teacher in 1910 to five by 1931. Tomball became an 11-grade school at that time. As soon as school started in the new building, it was already at capacity.

Immediately after the Cherry Street School completion in 1936, the same plans were used to begin building a high school in the 700 block of West Main Street. The property was donated by N.C. (Matt) Matthews, and the school was completed in 1938. The seniors of 1941 were the first to graduate from the 12th grade. (Photograph by Esther Bubley, courtesy the University of Louisville Archives.)

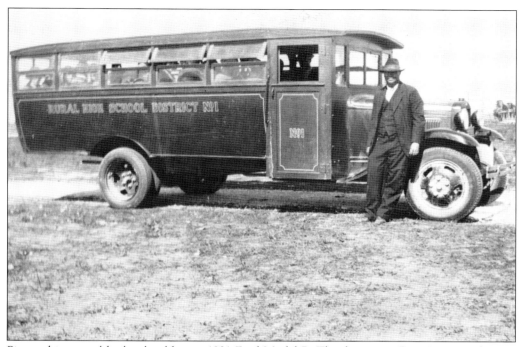

Pictured is a rural high school bus, a 1931 Ford Model B. The driver was Brett Harris, who was also a part-time teacher and custodian.

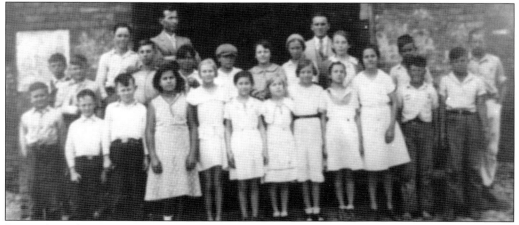

Pictured are the 1931–1932 seventh and eighth grades. On the left is Supt. Fritz McPhail, and on the right is principal Theo Bennett. (Courtesy Ouida McPhail Arnold.)

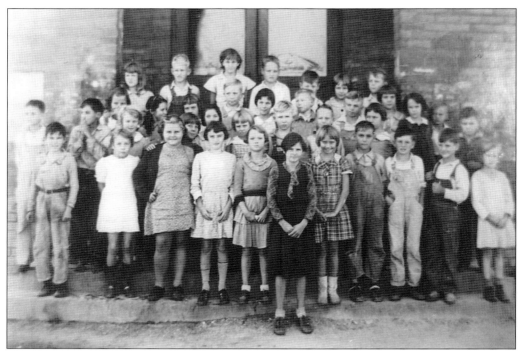

The third-grade class of the Cherry Street School is in this 1936 photograph. In the center front is teacher Florence Curtsinger. (Courtesy Ouida McPhail Arnold.)

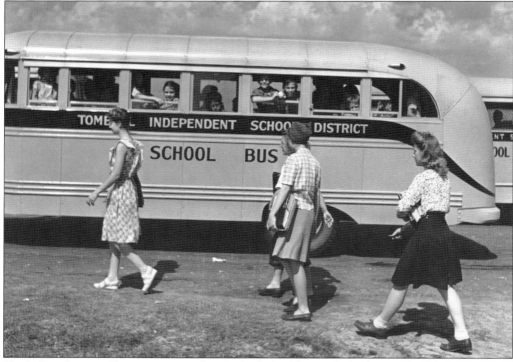

Tomball students and buses are pictured in 1945. The building in the background is the gymnasium of the Main Street School. (Photograph by Esther Bubley, courtesy the University of Louisville Archives.)

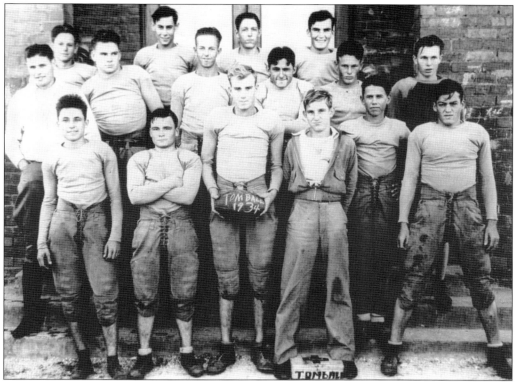

Tomball's first high school football team was formed in 1934. Fourteen athletes, a seventh-grade water boy, and a 21-year-old coach from Sam Houston comprised the team. The uniforms were second-hand from Jeff Davis High School in Houston. The team, water boy, and coach Pete Young met to discuss official colors and a mascot. At that meeting began the legacy of Cougar red and white for Tomball High. (Courtesy Mary Owens Coe.)

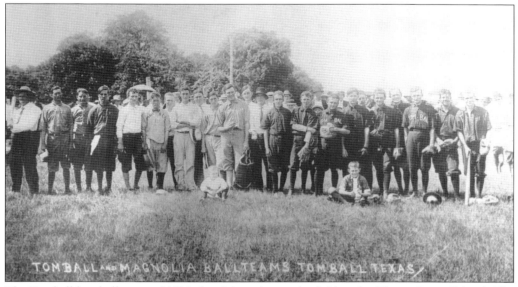

The Tomball baseball team of 1914 plays Magnolia on the field at the Cherry Street School. The boys did not know at the time that Magnolia would be one of their largest rivals in the years ahead.

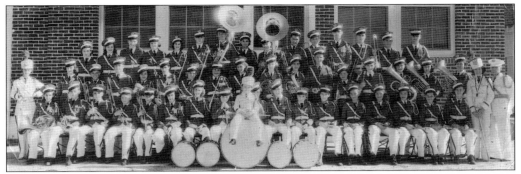

The first Tomball band was organized in 1937 with Wesley Slack as band director. The band mothers' club raised money to buy new uniforms. The first band was unique, as Tomball was the only school to have a traveling marching band. The band made appearances in the Houston Livestock Parade in 1938 and the following year was invited to perform at the Cotton Bowl in Dallas. (Courtesy Alice Etheredge.)

The Tomball High School band of the 1972–1973 school year is pictured here with the high school student body and staff on the new field on Sandy Lane. The new high school was completed in 1974. The band was directed by Leonard Chambers, who wrote the arrangement for the school song in 1953. (Courtesy Tomball High School.)

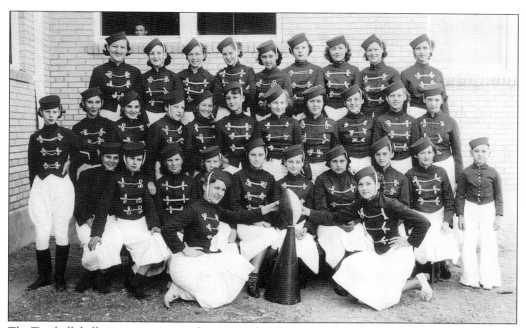

The Tomball drill team was organized in 1936. The uniforms were red and white gabardine, military style, and were worn for the first time in the Tomball Fair Parade. The team performed at three football games that first year and marched in the Houston Thanksgiving Day Parade. (Courtesy Tessie Winkle Weihrich.)

On Tuesday, February 7, 1961, the school clock in the west wing of the building stopped at 5:41 a.m. It is thought that is the time the fire broke out, reportedly from an electrical short. By 8:00 a.m., the fire was extinguished with five neighboring fire departments. Schools from all over Texas assisted with the disaster by providing textbooks and other materials. The building was rebuilt and reopened in October 1962.

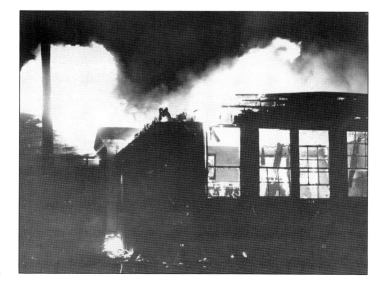

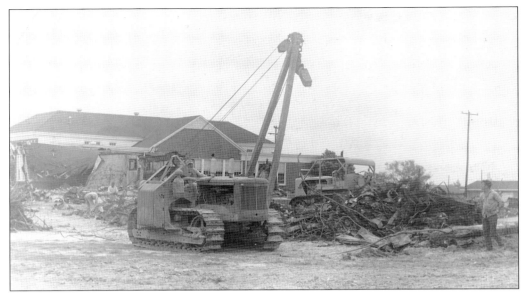

T&T Construction of Tomball cleared the area after faculty and students culled through the debris for any salvageable items. Due to the organization of the community, students only missed four days of school before classes resumed in other facilities.

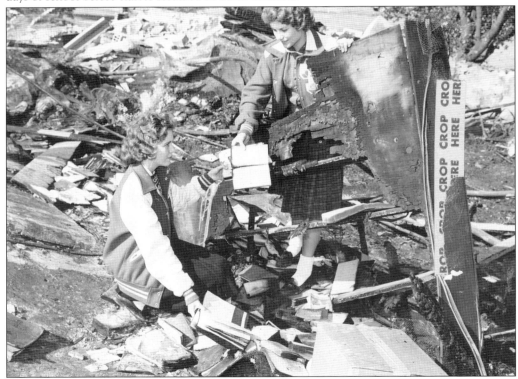

Pictured are Barbara Sojourner Bradberry (left) and Anna Kent salvaging books. Because of the four-and-one-half-foot elevation of the building, many library books were salvaged. As the floor gave way in the fire, library shelves tumbled face down, and the books were face down in the damp ground. (Courtesy Bettie Doughtie.)

The newly renovated high school gymnasium on Main Street is shown here in 1964. The fire of 1961 did not reach the gym due to the separated breezeway that attached to the school. The district took the opportunity after the new school was completed to upgrade some of the original areas of the gymnasium.

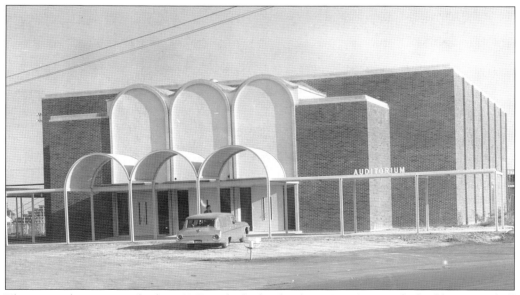

The new auditorium was built in 1962 at the high school on Main Street. The building served all school activities and was used for many years as the home of the Miss Tomball Pageant, concerts, and other community events.

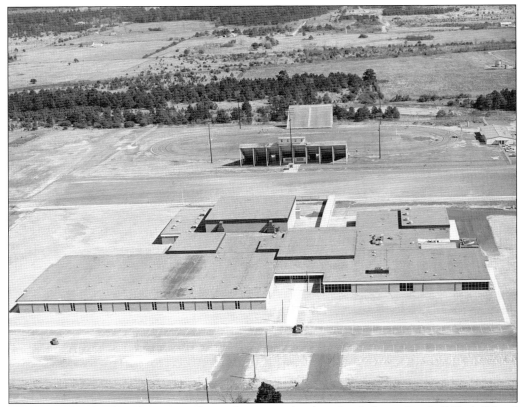

In 1974, high school students moved into their new school on Sandy Lane. Tomball High School remains on this property today, through several expansions. Growth continues to grace the district with the need to build more schools. (Both, courtesy Tomball Independent School District.)

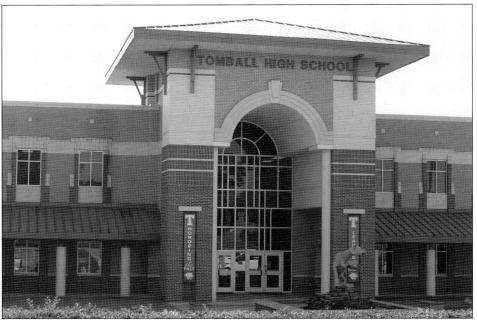

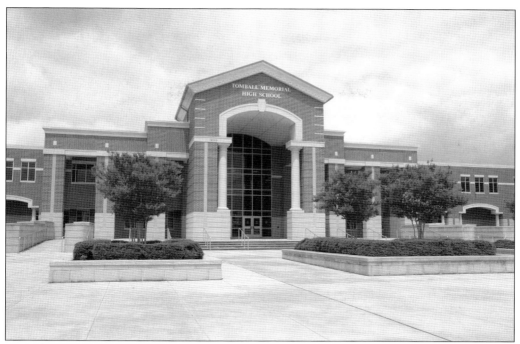

Growth south of Tomball continued to expand within the technology corridor, and a need for a second high school grew as well. Tomball Memorial High School opened in 2011, located on Northpointe Ridge Lane. (Courtesy Tomball Independent School District.)

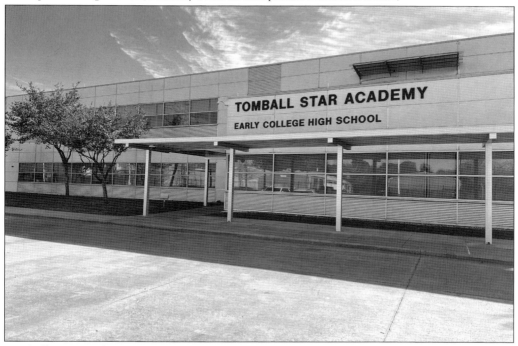

Tomball Star Academy Early College High School opened in 2017. In 2021, when the district purchased the Tomball Innovation Center on FM 2920, the school was relocated to that location. (Courtesy Tomball Independent School District.)

Functioning as a peaceful haven, a central place to meet and share ideas, the Tomball Library has always been a place to shape and grow minds. After decades of expanding growth and several temporary locations, through fundraising efforts of the Humble Study Club and the Friends of Tomball Library, Harris County opened this new branch library in 1972 on James Street. (Courtesy Harris County Archives.)

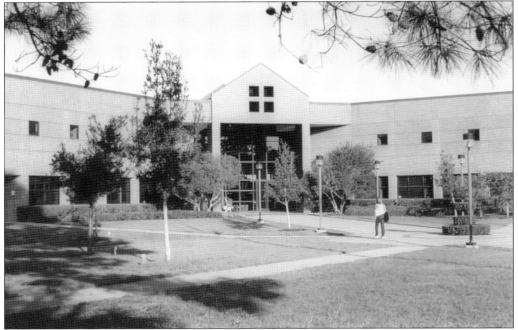

Opening in 1988, Tomball College's design took the form of a cruciform, reflecting the mission of the college and its employees: at the center is the Commons area, the heart of the college, representing its sense of community, and the four wings that branch off the Commons represent the desire of the college to radiate educational opportunities to the four corners of the community. (Courtesy Lone Star College–Tomball Community Library.)

Eight
Community Life

Having begun as a single successful railroad stop and then a land-selling venture, an agricultural success story, an oil-and-gas boomtown, and a central location in the technology corridor of the 1980s, Tomball's founders and educational and spiritual leaders seemed to have bridged the decades of success. These leaders reached across generations of founding families and connected to present-day citizens for a seamless transition of past history to create new chapters by keeping the town alive, thriving, and expanding. Because of the need to excel and expand, life in a small town will prosper and grow when there are the right people positioned to make a difference. This alone can be one of the reasons Tomball has become loved by so many who have lived here and moved on but remember the feeling of what this town continues to contribute. Community life in Tomball encompasses so many areas that another complete book about every event or place that has touched the public's heart could be compiled. What follows are a few memories and reminders of events or locations that show the small details that have sparked this town.

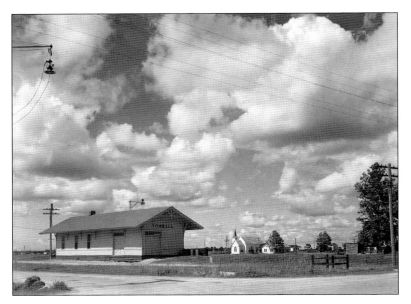

Seen here is one of the most famed photographs of an earlier era of the depot on the prairie, backed by a billowy sky of clouds. In the background is Tomball United Methodist Church. (Photograph by Esther Bubley, courtesy the University of Louisville Archives.)

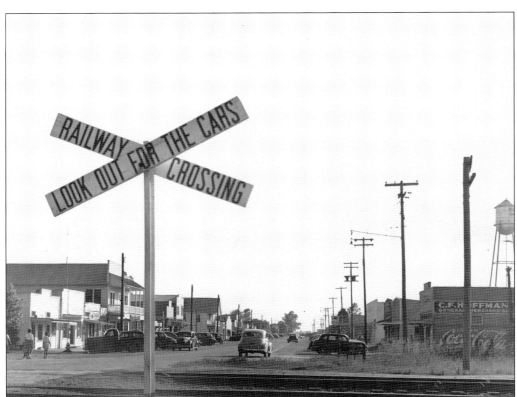

This 1945 view into town from the railroad tracks shows a prosperous small town lined with businesses, cars, and people living a storybook-type life. Directly over the tracks is Elm Street, the first street in Tomball to hold businesses. To the right is the Hoffman General Store, the original location of the Tob Henry Saloon. (Photograph by Esther Bubley, courtesy the University of Louisville Archives.)

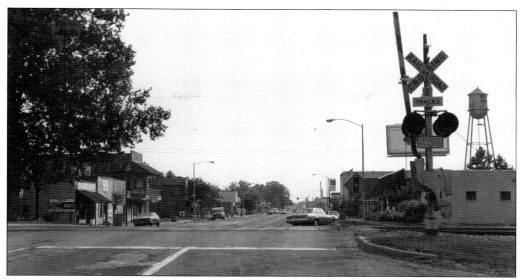

Seen here is Main Street in the 1970s. This is the same view as the previous photograph but taken 30 years later. (Courtesy Bob Miller Photography.)

This 1935 photograph depicts the well-known Theis filling station, located at the intersection of West Montgomery Road (now Highway 249) and Humble Camp Road. (Courtesy of Dan and Allie Theis.)

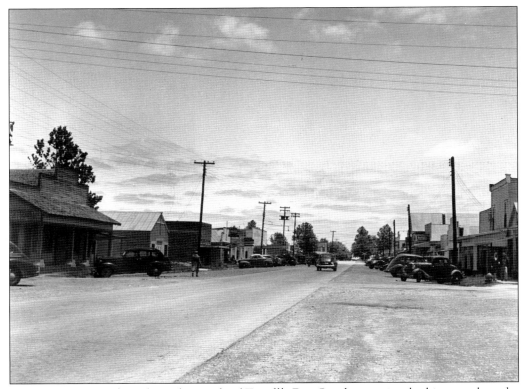

Main Street is seen here from the porch of Terrell's Dry Goods in a view looking north at the corner of Main and Cherry Streets in 1945. (Photograph by Esther Bubley, courtesy the University of Louisville Archives.)

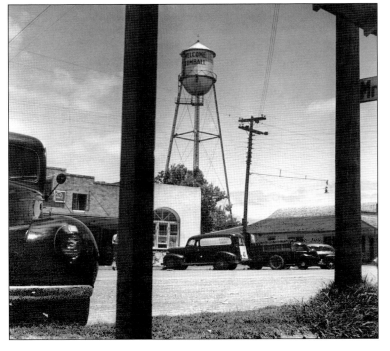

The Tomball water tower was an iconic symbol of small-town life that for many brought the reminder that "we're home" when it was sighted coming into town. The water tower was built in 1937 at the request of the Humble Company. Humble drilled the 700-foot well for the city. (Photograph by Esther Bubley, courtesy the University of Louisville Archives.)

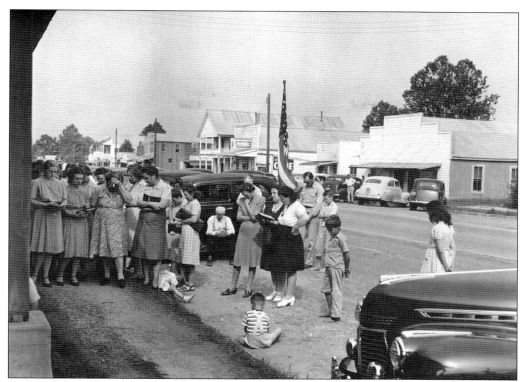

Pictured is a prayer service on VE (Victory in Europe) Day on May 8, 1945. Mayor Cecil Faris addressed residents and led those in attendance in prayer from the porch of Terrell's Dry Goods. (Photograph by Esther Bubley, courtesy the University of Louisville Archives.)

A yearly event for Tomball since the early 1950s was the welcoming of the Sam Houston Trail Ride through downtown, as riders headed to the Houston Livestock Show and Rodeo. The chamber of commerce welcomed them to town, and area businesses provided food and drinks to the riders in this photograph.

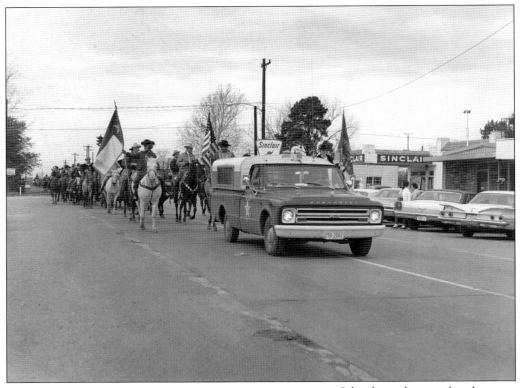

School was dismissed and businesses released employees so everyone could enjoy the parade of trail riders. Many students remember wearing their Western clothes and gear on parade day and looked forward to going to Main Street to cheer the cowboys and cowgirls on.

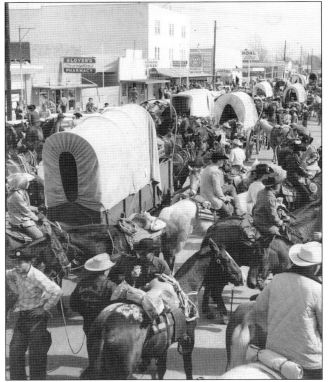

The trail riders still choose to make a stop in Tomball each year and are celebrated by local dignitaries, the city, the chamber, and the community. This photograph was taken looking west on Main Street at the north corner of Oak Street.

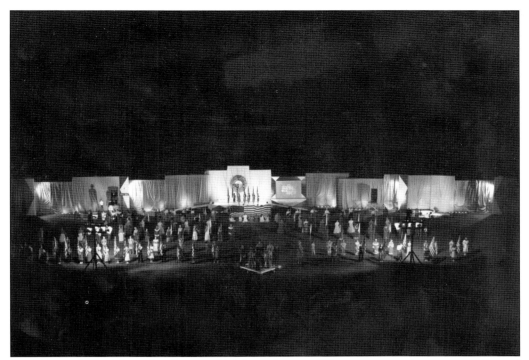

In 1982, Tomball celebrated its Diamond Jubilee in honor of 75 years as a city. A committee planned a month-long celebration of festivities, including a nightly production of short plays showing how the city started and different eras of growth. The book *A Tribute to Tomball* was published showcasing historical photographs and facts along with current images and histories of area families. (Courtesy Greater Tomball Area Chamber of Commerce.)

In 1973, Texas governor Dolph Brisco presented Tomball with the Governor's Community Achievement Award. The award was given to Tomball for outstanding achievements in historical preservation and the ongoing projects committed to growth.

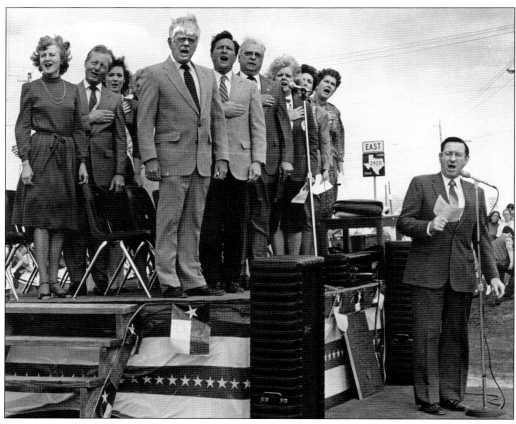

In March 1986, the Tomball Sesquicentennial Committee celebrated the city's 150th anniversary by presenting a plaque and three flag poles that were placed at Four Corners in honor of the people of Tomball. Presentation guests included Judge John Lindsay, Mayor Lee Tipton, Greater Tomball Area Chamber of Commerce president Diane Holland, and members of the committee. Leading the national anthem is Leonard Chambers, Tomball High School's music director.

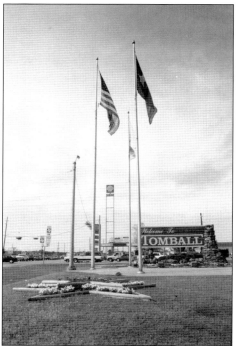

Four Corners continues to be a focal point for the community surrounding the three flagpoles. The Greater Tomball Area Chamber of Commerce displays holiday decor in the grassy area, including a planted cedar tree for decorations, banners for different events, and logos representing various organizations in Tomball.

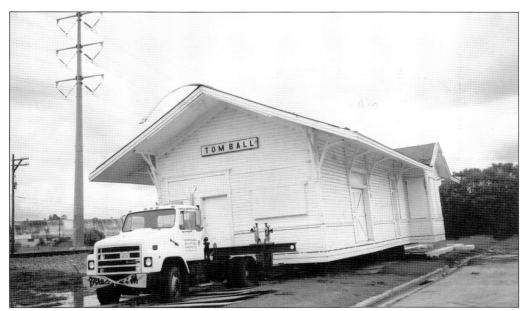

In 1993, the City of Tomball entered an agreement with Harris County commissioner Jerry Eversole to relocate the train depot to Burroughs Park on Hufsmith Road to save the depot from destruction. A state grant allowed for a new roof and fresh white paint for the building. Eleven years later, the depot returned less than one block away from its original location to a downtown historical area named Depot Square.

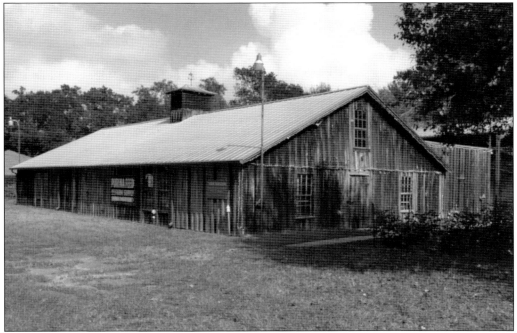

An important part of Tomball's historical preservation is the Tomball Museum Center, maintained by the Spring Creek County Historical Association. This barn was built to house an 1870s one-horse cotton gin owned by the Wuensche family of Spring and is thought to be one of two animal-powered gins remaining in Texas. (Courtesy Tomball Museum Center.)

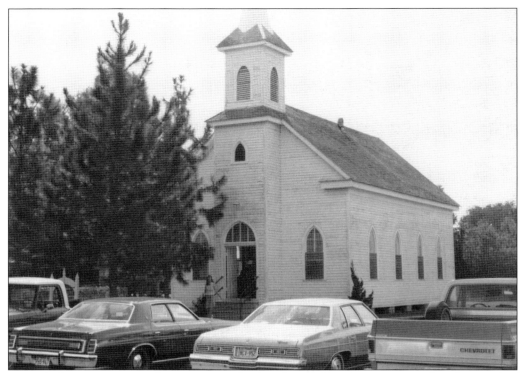

In 1876, the congregation of Trinity Evangelical Lutheran Church was organized in the Neudorf community southwest of town. This church was completed in 1905 and was moved with its original furnishings to the museum center in 1973. One regular service a year is held in the church on Thanksgiving morning. It is currently available for weddings. (Courtesy Tomball Museum Center.)

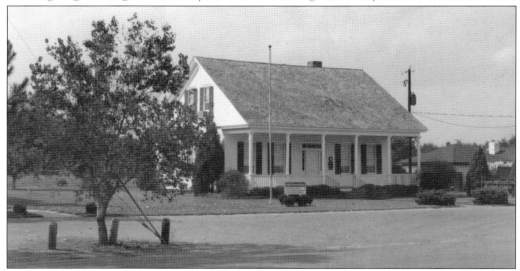

In 1860, Eugene Pillot built this home near present-day Boudreaux Road. In 1920, John Griffin purchased the home, and eventually, his daughter and her husband, John Faris, called it home. It was donated to the museum in 1965. The Charlton family, founding members of the museum association, were mostly responsible for moving and restoring the house, which is furnished with the belongings of their daughter Magdalene. (Courtesy Tomball Museum Center.)

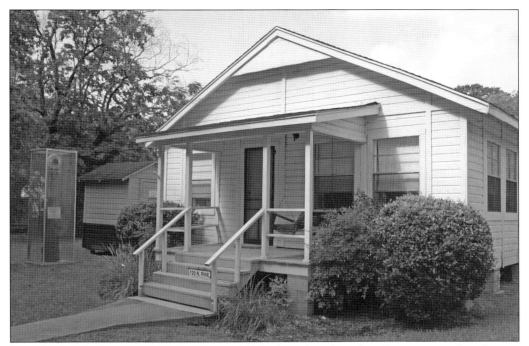

Acquired in 1998 through the generosity of the Oil Patch Kids and an Exxon grant, the oil camp house features prime oil boom-era decor and memorabilia, providing a great reminder to those who called Humble Oil Camp home. (Courtesy Tomball Museum Center.)

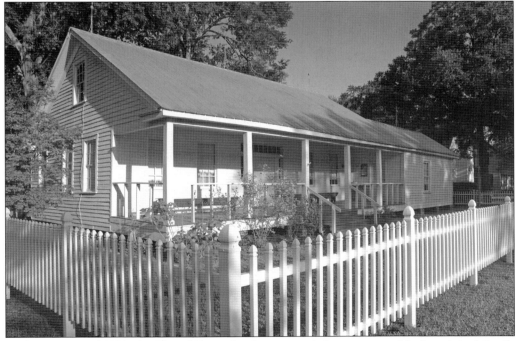

In the summer of 1989, the Theis/Theiss family presented the museum with the original family home dating back to 1869. The farmhouse gives visitors an authentic view of life as lived by the early German settlers in the area. (Courtesy Tomball Museum Center.)

Over the years, the Greater Tomball Area Chamber of Commerce has created mottos to coincide with special events in celebration of the town and its people. Bumper stickers were a hot item at times and were proudly displayed in business windows and homes and were even reported as being sighted on a number of city light control boxes.

Nine

FAVORITE AND FAMILIAR PLACES

This chapter needs no introduction to past or present citizens of Tomball, but for those who have not walked the paved streets nor entered a local business, imagine seeing or remembering the smell of a favorite place cherished during a certain period of life. Whether it was the creaky front door, the welcoming smile, the smell of the food, or the favorite parking spot, the following photographs bring those types of memories for residents of Tomball far and wide. We hope that this pictorial history of Tomball has brought enjoyment.

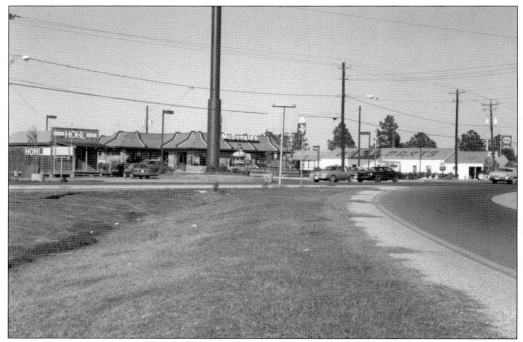

The intersection of FM 2920 and Highway 149 is known as Four Corners. Businesses in this photograph include Hohl Real Estate, McDonald's, and Walker Auto Parts, positioned on the northeast corner of the intersection.

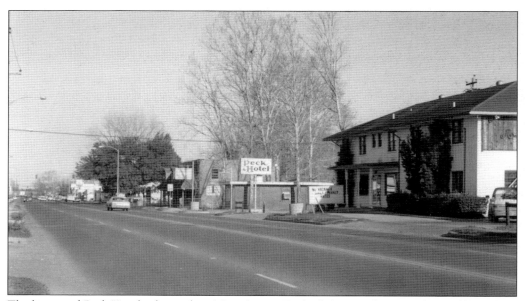

The historical Peck Hotel is located on Main Street. To the left was a florist in the small building, followed by the offices for the *Tomball Tribune/Potpourri* newspaper.

Pictured here are Safeway, Gibson's, and Guaranty Bond State Bank. These businesses all faced west on the south side of FM 2920 and Highway 149.

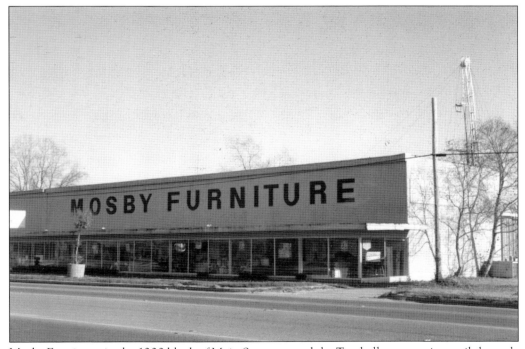

Mosby Furniture, in the 1000 block of Main Street, served the Tomball community until the early 1990s and was owned by Robert Mosby. The store was on the south side of Main Street, across from Gloyer's Pharmacy.

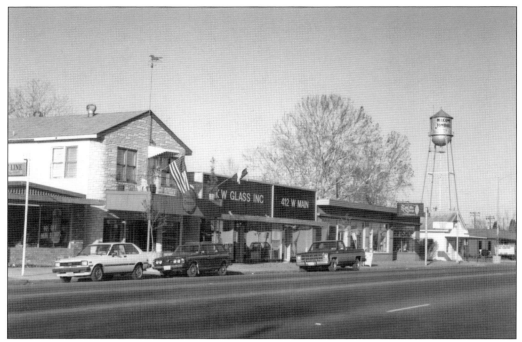

This is an early-1970s view of the original area of downtown, which provides home to several antique dealers in the community today. The view is of the north side of Main Street between Oak and Pine Streets.

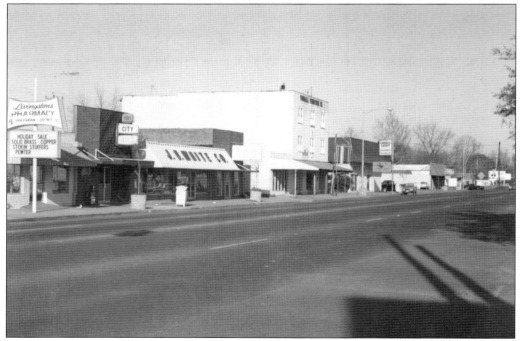

This is the north-side view of Main Street between Cherry and Walnut Streets in the 1970s. Clearly shown are the familiar storefronts of Livingston's Pharmacy, the City Café, and J.B. White's. The two-story white building is the original Brick Hotel, now home of Holderrieth Furniture Company.

Tomball Ford is pictured in its original location on Highway 149 next to Guaranty Bond State Bank. The owner, Tom Keating, and his family were part of the Tomball community, and Tom's son Ben took over the dealership many years later.

B&J Automotive was located on the north side of Main Street at Baker Drive. This business is still open today, specializing in muffler and exhaust repairs.

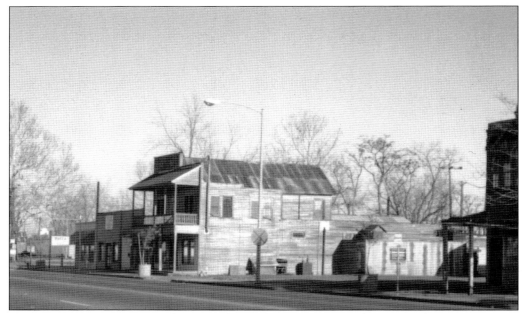

This view of Main Street near the railroad tracks looks south toward Brautigam's IGA Store. Even in the early 1970s, this original area of downtown was slowly losing the original wood buildings, as seen in the large space to the right.

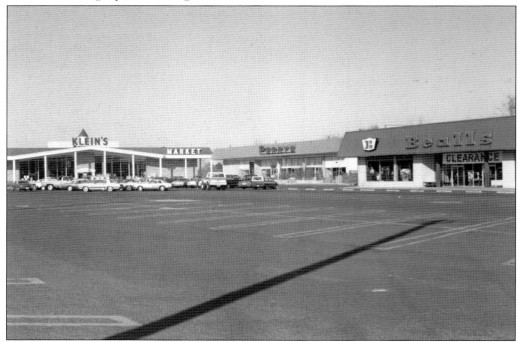

Klein's Super Market, an 88-year icon in Tomball, was first built at the corner of Main and Cherry Street, then moved to 1200 West Main Street at Buvinghausen Street in 1969, as shown in this photograph. The owners were Robert and Ruthie Klein. Next to the new grocery store shown are Perry's and Bealls Department Stores. The Klein family closed the store in 2010 to much community sadness. The building today is the Tomball VA Clinic.

This image of Four Corners at FM 2920 and Highway 149 shows the town sign. In the background is the iconic oak tree that stood for many years, providing shade for all that stopped for the various fruit or vegetable stands.

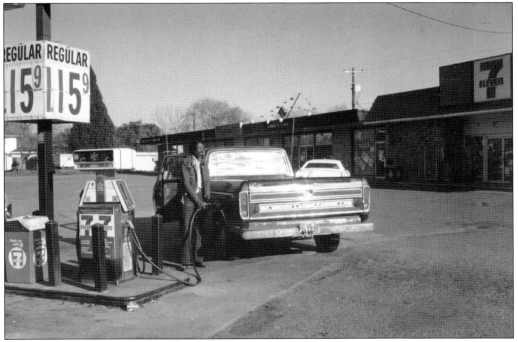

The 7-Eleven service station and strip center located on the southeast corner of Main and Poplar Streets is shown here in the early 1970s. The store has changed names over the years but is still open today as a convenience store.

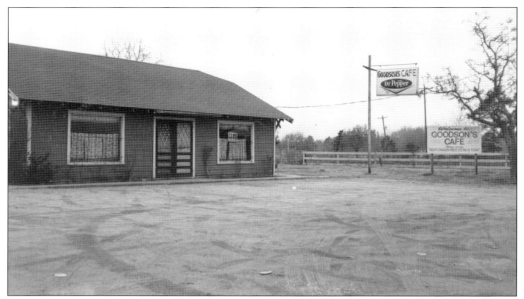

The original Goodson's Café in Hufsmith has always been legendary and known throughout Texas for Ma Goodson's amazing chicken-fried steaks. Moving to Tomball in 1985 to a two-story brick building under the ownership of Charlie and Jimmy Fogarty, it continued to serve great homemade food and expanded, moving into a new building on the property in 1996. Goodson's is still a community icon today.

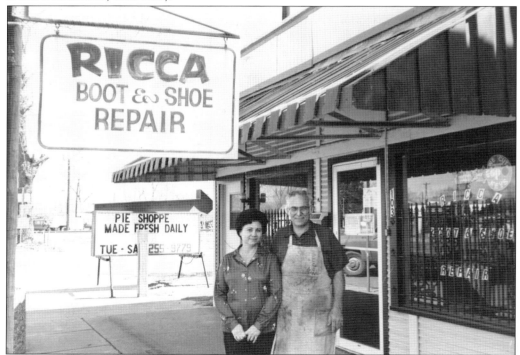

Ricca Boot and Shoe Repair is located at 103 West Main Street next to railroad tracks at Elm Street. Opened in 1976 by Sam and Marie Ricca, it is still owned today by their grandson Ryan, who creates custom boots.

Tomball Animal Hospital is owned by Tony and Gloria Folton. The Foltons have taken care of pets for many years, and the business is still open today, run by their daughter, Dr. Jana Folton.

T&T Construction Company, on the east side of the railroad tracks near Hufsmith, was started by T.T. Moore in 1946. T&T was the excavation company hired when Tomball High School burned in 1961.

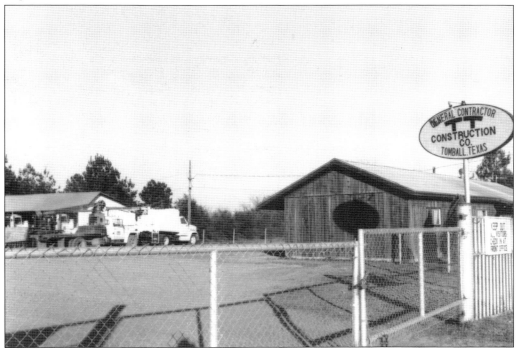

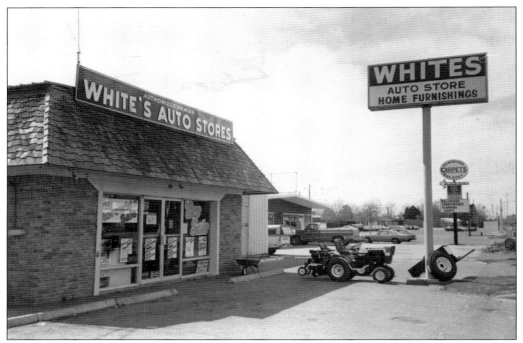

Pictured are White's Auto, located at 703 West Main Street on the south side near Poplar Street, and Cameron's Carpets in the background. The White's building is still open today as a hardware and mechanical supply business known as D&S Lawn and Automotive.

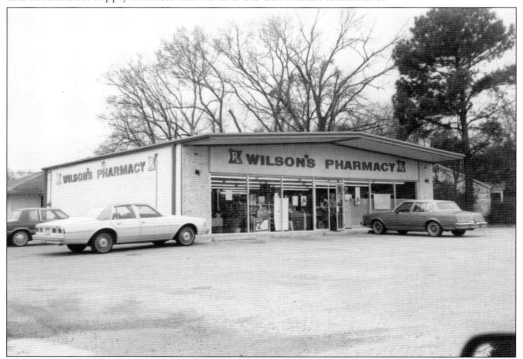

Wilson's Pharmacy was located at 901 West Main Street at Holderrieth Street. Years later, this building became home to Skelton Office Supplies.

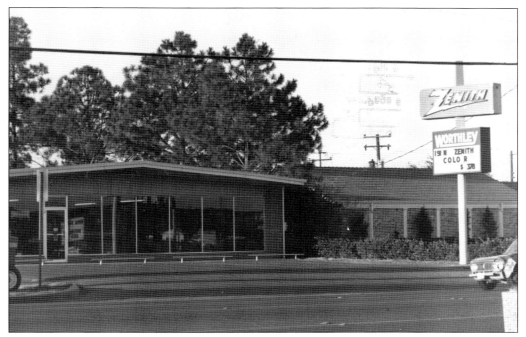

Worthley Appliance is located at 1404 West Main Street, on the north side next to Klein Funeral Home. Originally the home of Dugan's Appliances, Worthley's has been servicing Tomball's appliance needs for over six decades.

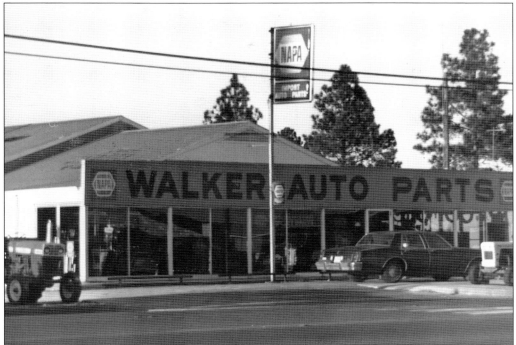

Walker Auto Parts, located at 1402 West Main Street, was on the north side next to Worthley Appliance. Today, the building has been replaced, but this location is still an automotive parts store known as NAPA Auto Parts.

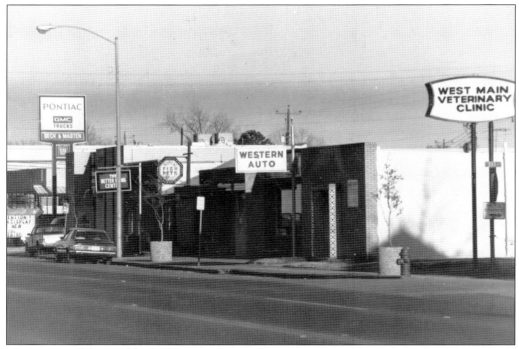

This view is of the 300 block of Main Street on the south side, near Oak Street. This is the corner where the Leon Hospital once stood.

Fischer's Auto Parts was located on Highway 149 just north of FM 2920 at Four Corners. Fischer's was one of the favorite places for high schoolers to work during the 1970s and 1980s.

Tomball Feed Center was situated on the east side of town on Main Street at Live Oak Street. Tomball Feed remained in business for many years and finally closed in the late 1980s.

McCauley Lumber Company was located at FM 149 south of Four Corners. McCauley's served Tomball residents for many years with building materials and stood south of the current Walmart.

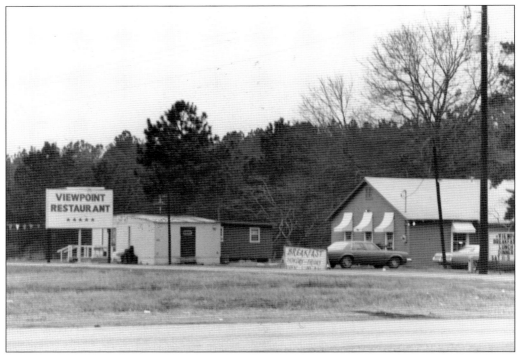

Viewpoint Restaurant, which was owned by Ken and Angie Elmore, was on the west side of Highway 249 in the area now occupied by Lone Star College.

Guinn Cleaners was located on the north side of Main Street at Oak Street. This building is still standing today, even though it has changed owners and business types several times.

Coats Jewelers was owned by Jim and Mary Coats. Coats provided many Tomball residents with friendly service and fine jewelry, and they were a highly regarded family in the community.

Dairy Queen was situated on the north side of Main Street near the current Gloyer's Pharmacy. The building still stands today and has been several restaurants over the past two decades.

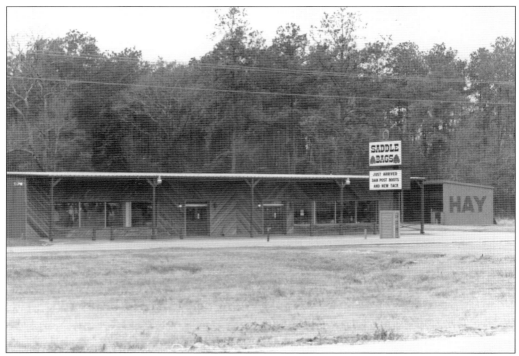

Saddle Bags Western Wear was located at Highway 149 north of FM 2920 on the west side of Sandy Lane. Not only a local favorite for Western wear for many years, it also offered tack and feed and had plenty of parking for those who brought their horses and trailers shopping.

Tomball Veterinary Clinic was located on the west side of Highway 149, north of the FM 2920 intersection. Dr. Gregory Bogart was another hometown favorite for taking care of family pets.

Pictured is the shopping center on Alma Street at Main Street. This center still stands today, with the popular CC's Café taking the place of everyone's favorite Pizza Factory.

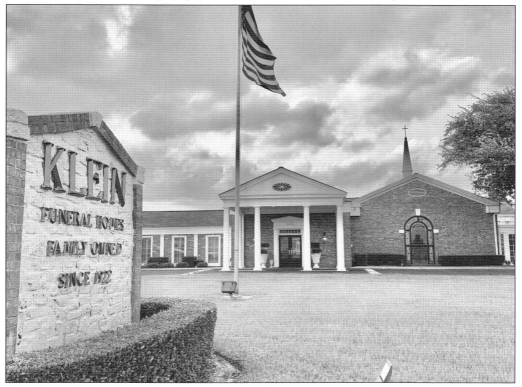

Klein Funeral Home, located at 1400 West Main Street, was originally owned by Teddy and Leora Klein. This location replaced the first funeral home in Tomball in 1965. It is now managed by Matthew and Mark Klein.

Wheeler Coe Realtors opened in the spring of 1964 at 419 West Main Street. In April 1968, Wheeler was elected city mayor. At 28 years old, he was the youngest mayor in Texas at the time, serving one term. Moving the business in 1970, as shown in this photograph, this new location anchored Four Corners on the northwest side. Coe is still actively selling real estate today.

Smitty's Drive In, located at 710 West Main Street, was a favorite hangout for many years for area teens. Owner Joe Svrcula was a friend to one and all.

This location was one of the first offices for Frey's Real Estate, which later developed such subdivisions as High Meadow Ranch and High Meadow Estates.

JR&S Cleaners was located at 708 West Main Street. JR&S served the community for many years, providing tailoring and same-day cleaning.

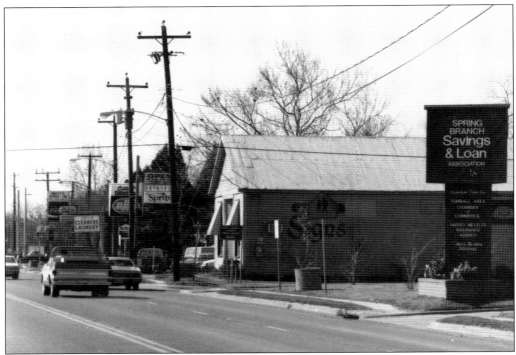

Coleman Sign Company stood at Main and North Poplar Streets. This building was the original addition to the Hirsch Feed Store.

Gloyer's Pharmacy was at 1010 West Main Street and was built by Wayne and Karin Gloyer in the mid-1960s. The Gloyers were another highly regarded family of Tomball that built their business by caring for the people of Tomball's pharmaceutical needs.

Beck and Masten Pontiac sat on Main Street at South Cherry Street. What was once a small-town dealership is now located on FM 1960 in Houston, serving thousands of Houstonians with a large GM-branded dealership.

Neidigk Lumber Company was located at 110 West Main Street. The Neidigk family's lumber heritage in the Tomball area spanned five generations, starting with C.W. Winkler, continuing to his son-in-law Oscar Neidigk, and through brothers Fredrich, Lester, and Dale Neidigk, finally closing in 2015.

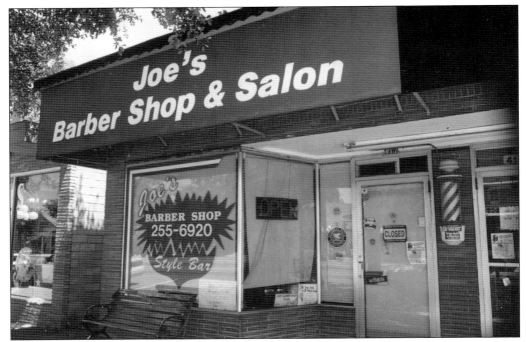

Joe's Barber Shop stands at 417 West Main Street. Joe's is still open today under the same name, delivering top-notch and caring barber services to the community.

The Goal Post, located at 705 West Main Street, was a favorite burger hangout from the 1950s through the 1970s. The building, located near the Main Street School, was a convenient place for students for many years to eat, socialize, and play the jukebox.

The water tower, which said "Welcome to Tomball," was a landmark for residents since 1937. Residents scaled the tower as a dare or just to celebrate the climb. Many left artwork, while others simply competed to see who could throw a baseball over the tower. For others, it was the red blinking light on top that beaconed them home at night. The tower was demolished in 1991 for safety reasons.

Sonic Drive-in is located at 518 West Main Street. Many residents recall dragging Main Street as they made the loop from Sonic to Safeway repeatedly on Friday and Saturday nights.

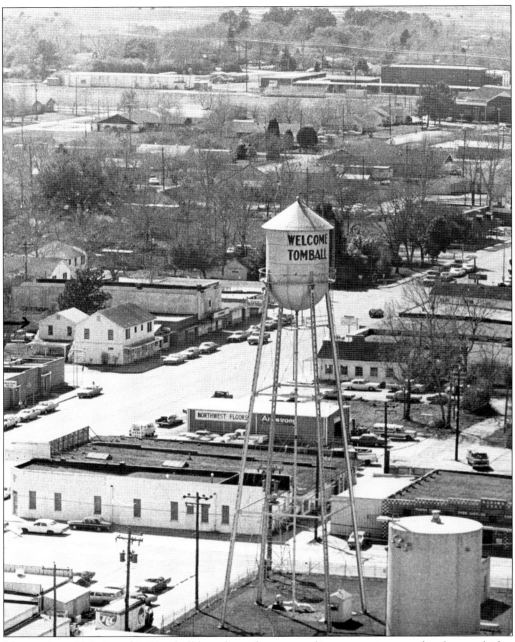

The quality of life found in Tomball has always been appealing, attracting people of many faiths, backgrounds, and skills. Through Tomball's growth from a railroad stop called Peck to the thriving city today, one common factor continues to be evident over the decades. It is a community of people living in harmony and trust with the common progressive goal to thrive and succeed—a community of good neighbors building a "Hometown with a Heart."

Bibliography

Alan Jones, ed. *Tomball Celebrating 100 Years.* Tomball Potpourri, 2007.
Bubley, Esther. Standard Oil of New Jersey Collection, 1945. University of Louisville Archives.
Harrington, Shirley Klein, ed. *A Tribute to Tomball: A Pictorial History of the Tomball Area.* Tomball, TX: Tomball Area Diamond Jubilee Committee, 1982.
Linebarger, Clarence A., Forrest W. Linebarger, and Clayton C. Linebarger. Collection (MC 946), Box 33, Folder 15: photographs 57, 58. Special Collections, University of Arkansas Libraries, Fayetteville.
Livingston, Craig. *The History of Lone Star College: Fifty Years of Excellence, 1972–2022.* The Woodlands, TX: Lone Star College System, 2021.
Tomball Centennial Commission. *Tomball: Hometown with a Heart: 1907–2007.* Tomball, TX: Metropolitan Publishing Company, Inc., 2007.
Upchurch, Lessie. *Welcome to Tomball: A History of Tomball, Texas.* Houston, TX: D. Armstrong Co., 1976.

Discover Thousands of Local History Books
Featuring Millions of Vintage Images

Arcadia Publishing, the leading local history publisher in the United States, is committed to making history accessible and meaningful through publishing books that celebrate and preserve the heritage of America's people and places.

Find more books like this at
www.arcadiapublishing.com

Search for your hometown history, your old stomping grounds, and even your favorite sports team.

Consistent with our mission to preserve history on a local level, this book was printed in South Carolina on American-made paper and manufactured entirely in the United States. Products carrying the accredited Forest Stewardship Council (FSC) label are printed on 100 percent FSC-certified paper.